EDITED BY ALYSE NELSON
PAINTINGS BY GAYLE KABAKER

VITAL VOICES

100 WOMEN USING THEIR POWER TO EMPOWER

ASSOULINE

TABLE OF CONTENTS

6	Foreword By Amanda Gorman	62	Megan Rapinoe
8	Introduction By Alyse Nelson	64	Jacinda Ardern
		66	Sallie Krawcheck
		68	Xiomara Diaz
14	Manal al-Sharif	70	Yin Myo Su
16	Xiye Bastida	72	Kay Bailey Hutchison
18	Sara Blakely	74	Hindou Oumarou Ibrahim
20	Oby Ezekwesili	76	Hannah Gadsby
22	Diane von Furstenberg	78	Roshaneh Zafar
24	Esra'a Al Shafei	80	Sunitha Krishnan
26	Ruth Bader Ginsburg	82	Karla Ruiz Cofiño
28	Ariela Suster	84	Tarana Burke
30	Christine Lagarde	86	Andeisha Farid
32	Joy Buolamwini	88	Lina Khalifeh
34	Christy Turlington Burns	90	Sanna Marin
36	Donna Langley	92	Habiba Ali
38	Kakenya Ntaiya	94	Nadia Murad
40	Menaka Guruswamy & Arundhati Katju	96	Priti Patkar
		98	Melanne Verveer
42	Mai Khôi	100	Sharmeen Obaid-Chinoy
44	Hillary Rodham Clinton	102	Maria Pacheco
46	Greta Thunberg	104	Kah Walla
48	Samar Minallah Khan	106	Tina Brown
50	Guo Jianmei	108	Amani Ballour
52	Amanda Gorman	110	Oksana Horbunova
54	Saskia Niño de Rivera	112	Elsa Marie D'Silva
56	Michelle Bachelet	114	Jaha Dukureh
58	Theresa Kachindamoto	116	Shimrit Perkol-Finkel
60	Sheikha Lubna Al Qasimi	118	Ellen Johnson Sirleaf

120	Adi Tafuna'i	176	Claudia Paz y Paz
122	Nancy Pelosi	178	Madeleine Albright
124	Chouchou Namegabe Nabintu	180	Akanksha Hazari
126	Danielle Saint-Lôt	182	Faith Florez
128	Geraldine Laybourne	184	Rouba Mhaissen
130	Neysara	186	Hawa Abdi & Deqo Aden Mohamed
132	Jamira Burley	188	Melinda Gates
134	Mayki Graff & Suam Fonseca	190	Panmela Castro
136	Karlie Kloss	192	Sara Minkara
138	Hafsat Abiola-Costello	194	Phumzile Mlambo-Ngcuka
140	Laura Bush	196	Rola Hallam
142	Laura Alonso	198	Mary Robinson
144	Jessica Hubley	200	Adriana Hinojosa Céspedes
146	Sohini Chakraborty	202	Mu Sochua
148	Geena Davis	204	Jennifer Siebel Newsom
150	Baljeet Sandhu	206	Malala Yousafzai
152	Marina Pisklakova-Parker	208	Bozoma Saint John
154	Victoria Kisyombe	210	Gina Barbieri
156	Leah Lizarondo	212	Claudia López Hernández
158	Deborah Rutter		
160	Amira Yahyaoui	214	Biographies
162	Amanda Nguyen	216	Acknowledgments
164	Yoani Sánchez		
166	Laura Liswood		
168	Kiran Bir Sethi		
170	Meghan Markle		
172	Christelle Kwizera		
174	Chessy Prout		

FOREWORD

VITAL VOICES
BY AMANDA GORMAN

Today, everyone's eyes

Are on us as we rise.

Today is the day women

Are paving the way,

Speaking our truth to power.

In this hour, it is our duty

To find the brave beauty

In rooting for other women

So they too know we are not victims,

We are victors, the greatest predictors

Of progress. We press for change,

A new dawn drawn into the open

By women whose silence is broken.

We push on and act on

Our responsibility to bring visibility

To the most vulnerable:

To bring freedom to those who didn't have a choice,

To bring volume to those who are using their voice.

We clear a woman's way,

We don't fear the day

She steps into the light

Because we are with her

Every step of the fight.

There's a lot at stake, but making

A difference always takes great courage.

So we encourage women who dare to stare

Fear square in its face,
Women who've always shown
That when one woman stands up
She is never alone.

We know that when she steps up to right a wrong,
She will fight to bring others along
To the network, into the conversation,
Working together to change communities
And nations for generations, our world
Made all the stronger the longer
Women are able to sit at the table.

It is her strength, her story, and her spirit
Which inspires other vital voices
To speak up when they hear it.

So let it be said that light will be shed
When our world is led by leaders ahead
Of the headlines, the voices
Who are first on the frontline,
These women who stand up,
Knowing the wind
Not by where it is, but where it is blowing,
Leading worlds not by how society is
But where change is going.
We all leap forward when one woman tries,
When she defies with her rallying cries.
Here lies, but does not rest, the best
Of tested women who call us all to rise,
Speaking the truth in this finest hour:

That to their own power,
Every single woman is entitled.
But it's how they empower others
That makes women's voices so vital.

INTRODUCTION
BY ALYSE NELSON

I have always believed in the power of women's leadership to change the course of human history. The turbulent events of 2020 further exposed systemic injustices and inequities that have been able to persist for far too long. We are forced to question how we have approached problems in the past and look deeply at what it will take to create true progress. The voices, the lessons and the leadership of women featured in this book are more relevant now than ever before.

As I write this, our world is grappling with a catastrophic threat. The coronavirus (COVID-19) has claimed countless lives, devastating families and communities in nearly every nation on Earth. Health services and economic systems are cracking under the weight of enormous, unparalleled pressure. Every sector and every industry has been affected; and even as we begin to see flickers of light at the end of the tunnel, we still have no way of knowing how extreme or long-lasting the consequences of this pandemic will be.

The stakes have never felt this high. We've watched, in real-time, the life and death results of leadership in action. In the middle of so much uncertainty, what's become clear, at this stage, is that certain leadership qualities are making the crucial difference.

Empathy, truthfulness, collaboration, ingenuity and decisiveness are front and center in leaders whose countries and communities are weathering this crisis best. And there's another quality that's shared by the most capable heads of state to date: They are all women. From Taiwan to Germany, Finland to New Zealand, female presidents and prime ministers have met this moment with strength and compassion.

These leaders have demonstrated the distinct leadership traits that you'll see reflected in the one hundred women featured in the pages of this book. While these qualities are by no means exclusive to women, they are consistently practiced by the thousands of leaders that Vital Voices has partnered with over the last two decades. Taken together, these traits form a unique style of leadership that our world needs now, more than ever.

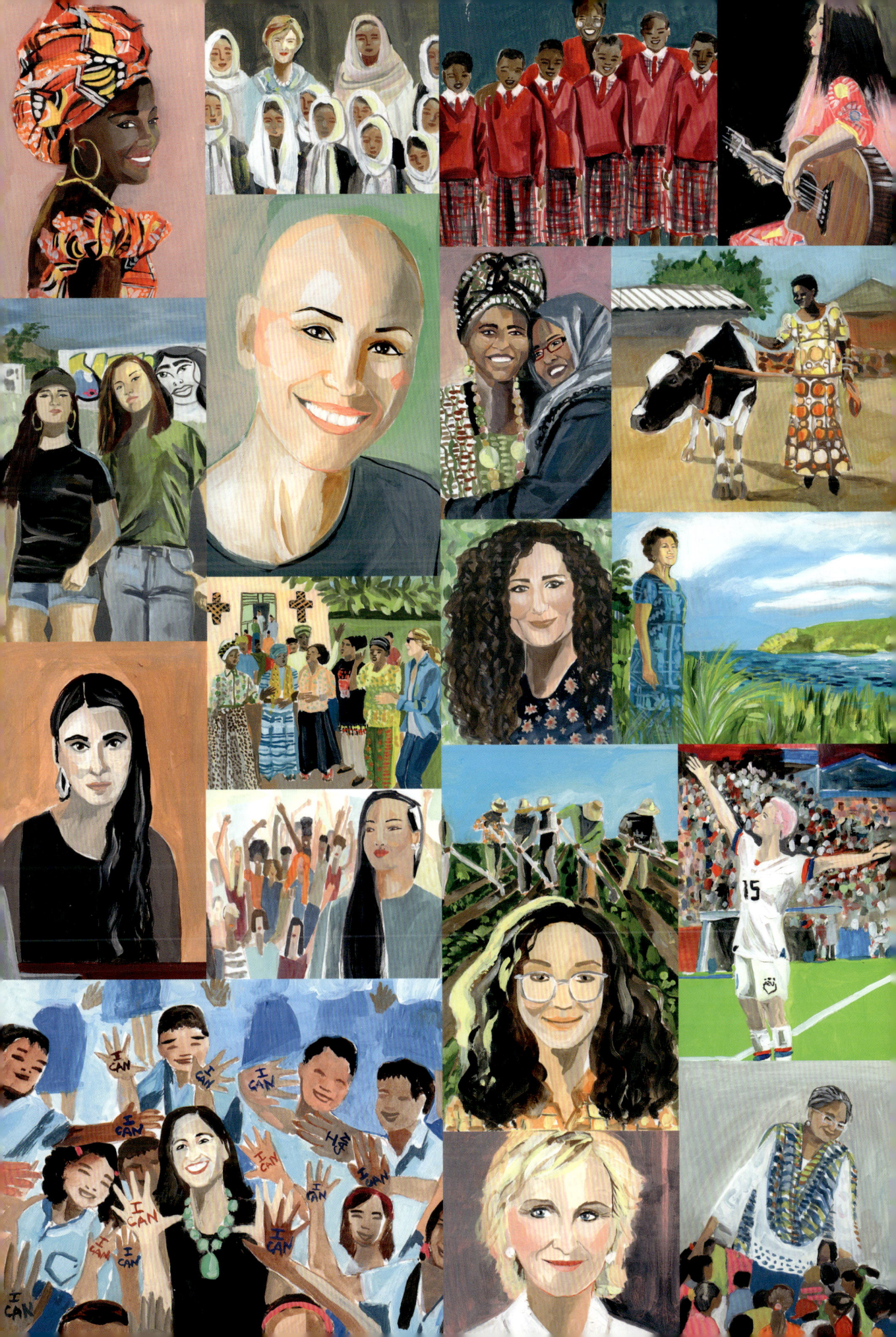

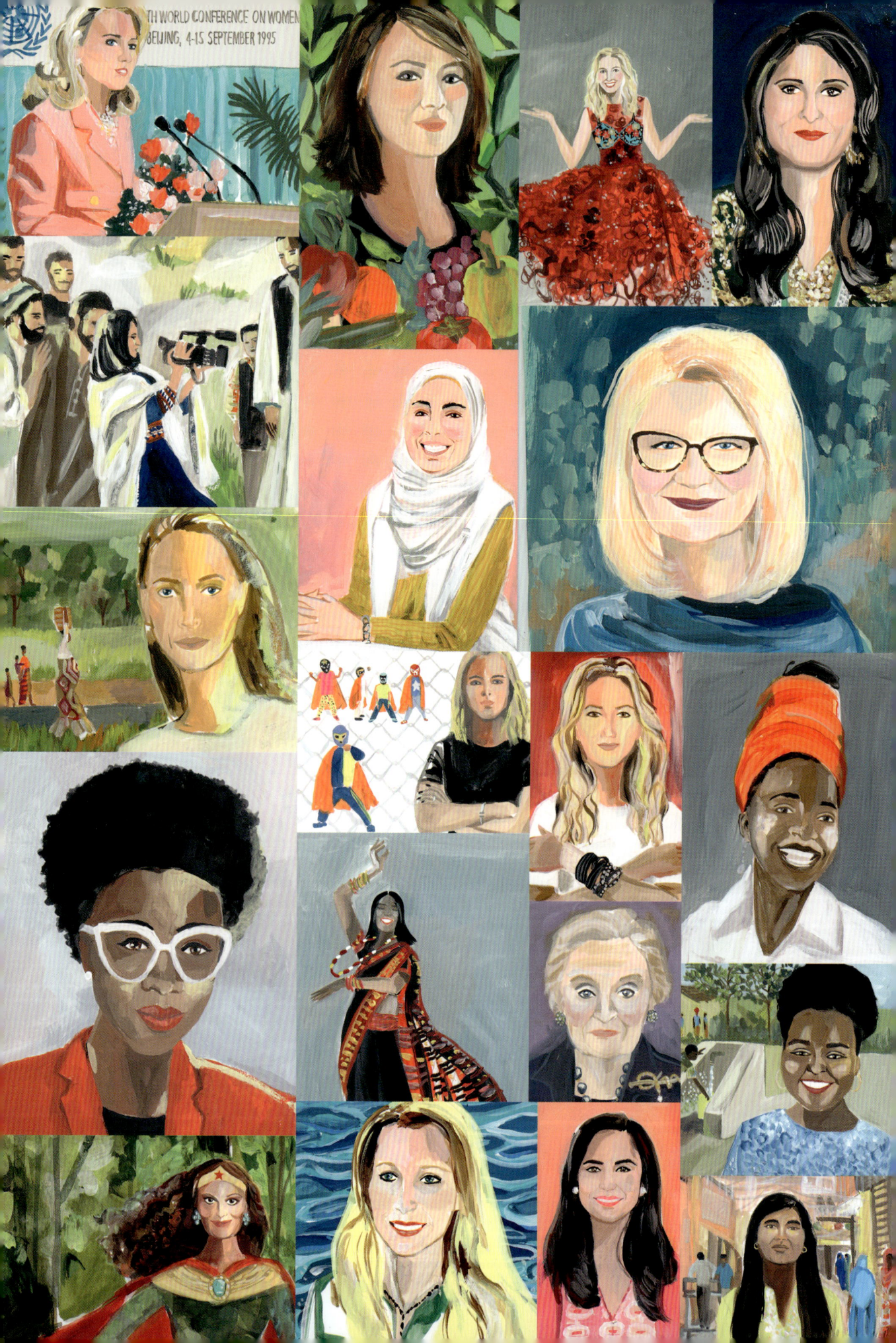

Across countries, creeds, and cultures, beyond age, race, or economic status, at Vital Voices, we have seen, time and again, that women who fight for social progress embody a model of five distinct leadership traits.

First, women lead with a deep sense of purpose, a driving force that propels them forward and shapes their vision for progress. Second, women leaders have strong roots in their community; they understand its problems and see its potential. Third, they're willing to cross lines that typically divide, forging unlikely alliances and making room for diverse voices, so that they can develop sustainable solutions. Fourth, women leaders embrace creativity and boldness; they're not afraid to explore alternative methods and set audacious goals. And fifth, women leaders consistently choose to pay it forward, investing in and mentoring the rising generation, proactively setting in motion a virtuous cycle of support and solidarity.

This book is not only a celebration of women leaders, it's a glimpse at what's possible if we elevate and expand women's leadership around the globe. And in our own backyards.

This very week, millions of Americans across the country have taken to the streets to demand action on racial injustice. In America, in 2020, far too many people believe it's controversial to state this simple fact: Black lives matter. And we know this is not just an American problem. Racism, and, in particular, anti-blackness, is a global crisis that we must confront alongside the fight for women's empowerment. Social justice and anti-racism movements are in large part being led by black women. We must, and will, elevate their voices and their ideas.

Because what's become abundantly clear is that today's world isn't set up to solve the challenges of tomorrow. The greatest problems our world faces—from access to quality healthcare and addressing climate justice, to tackling gender inequality and rooting out racial injustice—are deeply interconnected. We urgently need new ideas and new voices to lead us forward.

In the midst of crisis, we must remember that the most trying moments of our shared history have also been the ones that led us—often out of necessity—to breakthrough change. We have no choice but to do things differently. And I have never been more certain that women leaders are the difference we need.

For too long, women—and, in particular, women of color—have been sidelined. They have been overlooked and undervalued for the very reason that we need them most in this moment: They lead differently, bringing inventive solutions forward. Because these leaders have been excluded, they have adapted by becoming resourceful and creative. We need their innovative style of leadership to help us emerge stronger, because we cannot rebuild our world with conventional ideas.

Vital Voices was founded for women leaders and because of them. As you'll see in this book, in their own words, these leaders never waver from a challenge. Some, you will recognize as household names, whereas others are unsung heroes; whether they make the headlines or not, these leaders always make a difference. Perseverance, empathy, and a clarity of purpose were recurring themes in nearly every woman and girl's journey to leadership. These qualities, and many others, are so

beautifully represented visually in the stunning portraits of this collection, created by the talented artist Gayle Kabaker.

These are extraordinary times, but the momentum we've built up in the last twenty-five years—as a movement and as an organization—is anything but stalled. This year marks the twenty-fifth anniversary of the historic United Nations Fourth World Conference on Women, where the boldest agenda yet for women's equality was adopted. We've come so far since then, and yet still have so much further to go before we realize the goal of universal gender equity.

In America, this year also marks the 100thanniversary of the 19th amendment, which enshrined universal women's suffrage in law. But not in practice. Discriminatory practices continued to disenfranchise black women for another forty-five years, until the Voting Rights Act was passed.

These milestones remind us that progress is an ideal we constantly strive towards, it's a never-ending commitment, and a lifelong aspiration. As the global women's movement continues to evolve, we must reckon with our own failings, confront bias and exclusion wherever they appear, and resolve to do better. As women, we're called to keep fighting, keep striving, until every voice is heard

The remarkable leaders profiled in this book are getting us closer to that ideal. With courage and compassion, women leaders everywhere are already playing a critical role, helping their communities cope in crisis. And I have no doubt that women's leadership will be instrumental to forging the new reality we so desperately need.

We have to imagine our world anew. If we make every effort to advance women leaders, the new world we create will be more peaceful, equitable and free.

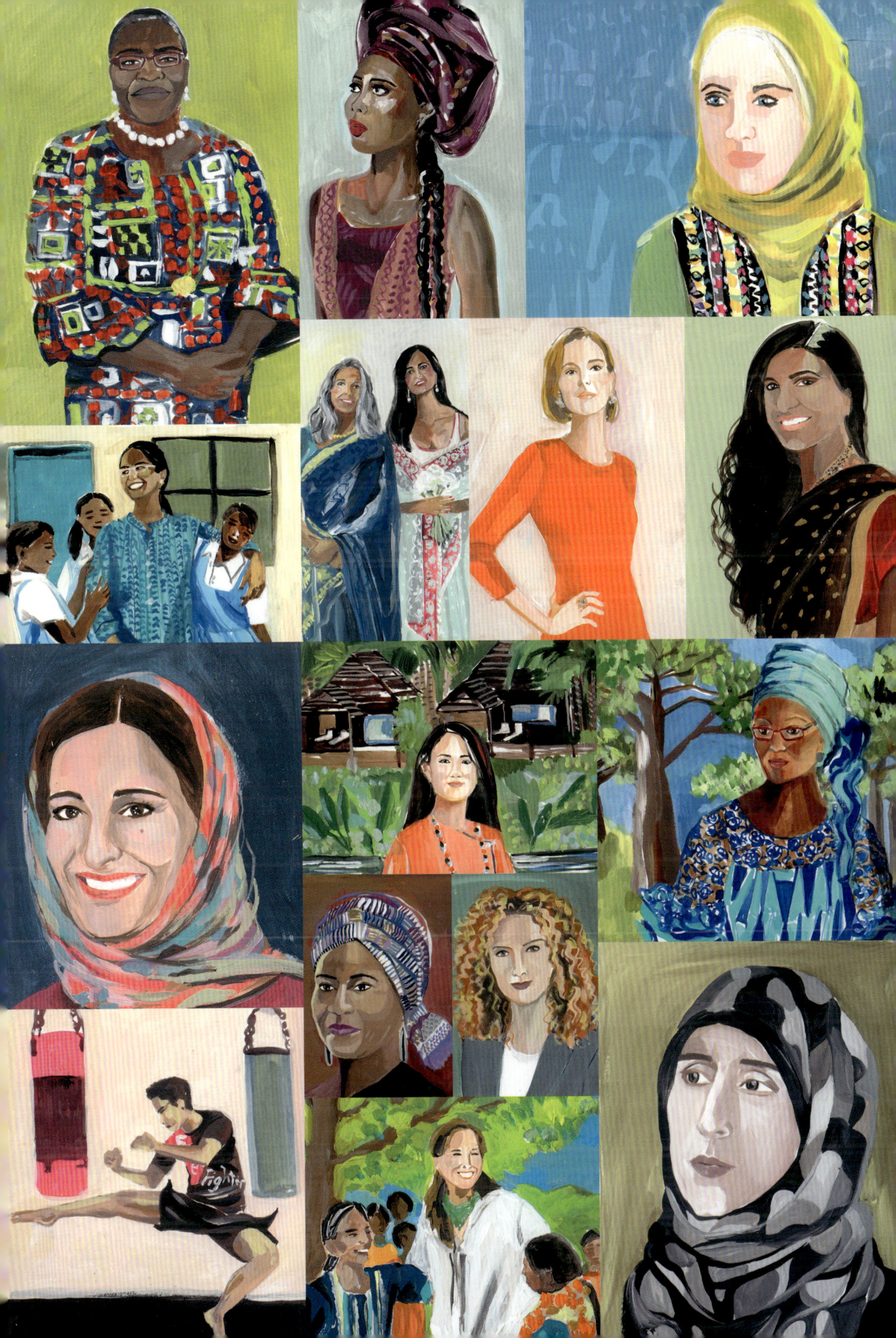

SAUDI ARABIA

MANAL AL-SHARIF

I DIDN'T BREAK ANY LAW. It was personal, very personal. The simplest explanation is that I was a single mom, working full-time, with a car that I couldn't drive. So, it wasn't just out of anger. It was a need.

My first book about feminism, I read in 2017; but I didn't know any of these things before. We were never taught about women's rights in school. So, when people started calling me "activist" or "feminist," I had no clue what those words meant.

I think feminism is when women realize something is unfair, or that something is wrong with the system, but because everyone around them says this is how things are, they don't question it. I was the one questioning it, without being exposed to feminism or women's rights.

I did the Freedom Drive because most women I watched were sent to jail and no one talks about them. But I found out that's what they want, the government. They want to shut us up. So, I had to speak.

Be yourself without permission. The world will always want you to be someone else. Disappoint it.

Once you go public, you become a public target. And the more attacks, the more impact. The attacks mean you are creating noise, that you are changing minds.

They'd just appointed the first female ambassador in the history of Saudi Arabia; and that ambassador still needed her guardian's permission to drive. So, I held up a sign: "Did you need permission to be here?" it read. Three months later, that law was overturned.

MANAL AL-SHARIF is a courageous activist who defied a cultural norm and was imprisoned after deciding to film herself driving in Saudi Arabia. She led a national campaign for women's right to drive.

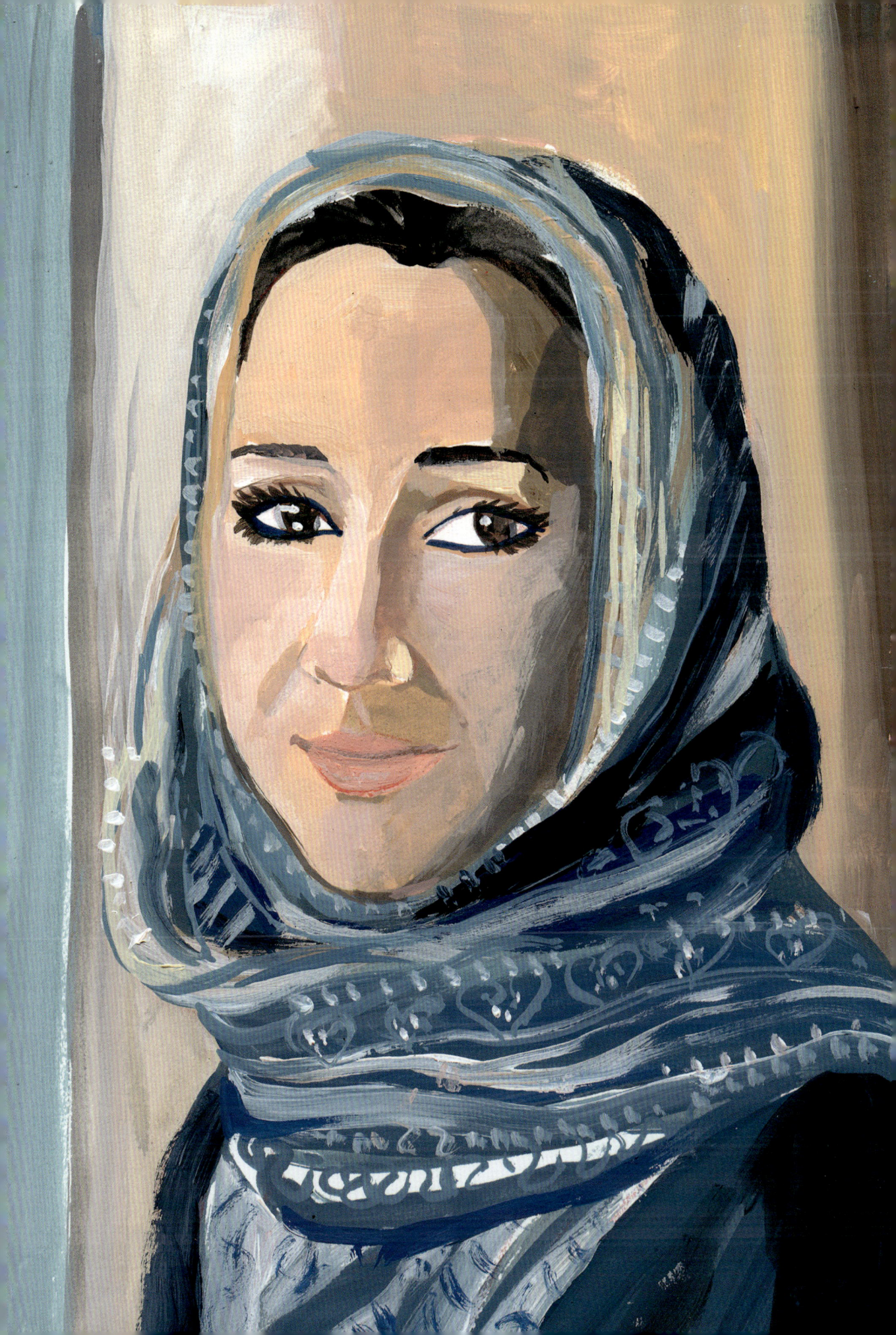

MEXICO

XIYE BASTIDA

MANY PEOPLE SEE THE CLIMATE movement as having gained a lot of momentum recently because of the youth movement. But we know as youth that we did not start the movement at all. We're just bringing an element of urgency. Indigenous Peoples have been taking care of the Earth for thousands of years because that is their culture, that is their way of life. For me, being an environmental activist and a climate justice activist is not a hobby—it's a way of life.

I was born and raised in a small town called San Pedro Tultepec. My town had experienced drought for two years, then all of a sudden, it started experiencing rainfall to the point of flooding. That was the first time I saw the effects of the climate crisis.

We're seeing extinctions of species every day. We see that the world around us is actually deteriorating, and we're not going to be able to live in a world that is clean and stable. That's why youth are rising up.

Change comes from our votes—not only in politics, but in business. The way in which we spend our money says a lot about what we care about, and it is a great way to systematically move towards a circular economy. We've been in the narrative of personal responsibility for too long, making people feel like they caused the climate crisis because they didn't recycle. But it is much deeper than that. It's about why companies are deciding to even pack their things in plastic and ship things across the world. So, as we become more conscious, we are going to change our habits of living, and that is going to bring change as well.

It's our generational responsibility to leave the world better than we found it. That's how I was raised. That's what my parents always told me. 'Leave this place better than you found it,' whether it's the bathroom or the kitchen or the planet.

XIYE BASTIDA is an indigenous Mexican, youth climate activist, and member of the Indigenous Mexican Otomi-Toltec nation, who has emerged as a leading voice for the inclusion of indigenous communities in environmental activism.

THE UNITED STATES

SARA BLAKELY

WHEN I HEAR THINGS like "you're crazy," or, "that will never work," I know I'm onto something. That's when I get most excited. I always take resistance as a compliment because I know I'm entering new territory—that's where the magic happens. You can't have innovation without bucking the status quo.

I followed very feminine principles in a very masculine business world and achieved great success. My hope is that I've shown society that there is an alternate path to business success. You don't have to wear a blazer to attend a business meeting and you don't have to annihilate the competition.

A world that's balanced with female leaders means more collaboration and less competition. It means less data and more intuition. It means all the things that were once labeled as weak are seen as strengths. I always say that as women, one of our greatest weaknesses is also one of our greatest strengths: being underestimated.

Many people think you need to lead with intimidation and competition, especially in business, but I've never subscribed to that. I've always operated with very feminine principles—kindness, vulnerability, empathy and intuition. No one ever says "empathy" made them successful in business, but it's what made all the difference for me. It was my empathy for the consumer that led me to innovations that not only changed my life but revolutionized an industry.

SARA BLAKELY is the founder of Spanx, Inc., who inspires women entrepreneurs to use their success for social change.

NIGERIA

OBY EZEKWESILI

I NEEDED TO UNDERSTAND what it meant to have a sense of purpose. From a young age, I wanted to be able to define myself by certain, non-negotiable values. Knowing myself, my spirit, and my character, has freed me up in life. It has enabled me to take resistance from those who do not share my values, by simply staying consistent and true to what I believe.

Power is the full expression of your values. It's the freedom to make choices and have agency to take actions based on your values.

I think that it's informal power that's enormously strong. With informal power, there is no formal office attached to what you do. But because of your strength of character, your integrity of purpose, the values that the community shares with you, people willingly agree to be influenced by your thoughts, words and actions; and because of these shared values, you have so much influence to push society in the direction that it ought to be going.

I see a difference in women leaders. Women's vision is always defined beyond themselves: There's this sense of the common good, this spirit of community. I see women leaders express that more.

Women have a way of looking out for the vulnerable, because they feel an affinity with vulnerable people. Women do not overlook the cries of young people, the needs of people living with a disability, the needs of minorities.

OBY EZEKWEZILI is a former presidential candidate, government minister and the founder of the Bring Back Our Girls Movement. She is working to rewrite the rules of political leadership in Nigeria and beyond.

BELGIUM & THE UNITED STATES

DIANE VON FURSTENBERG

WHEN I WAS GROWING UP, I didn't know what I wanted to do; but I knew the kind of woman I wanted to be—I wanted to be a woman in charge. In truth, being in charge is, first and foremost, a commitment to ourselves. I often say that the most important relationship in life is the one you have with yourself. Once you have a relationship with yourself, any other relationship is a plus and not a must.

I started really young: I had my first success when I was twenty-five years old. The wrap dress happened, and the rest was history. What motivated me first was to be independent. That dress turned out to be not only my key to independence, but it was selling confidence to other women. There was an incredible dialogue between me and other women. It was very much a moment of liberation for women. And the dress became a symbol. People say I made the dress, but really, the dress made me.

I have been thinking about, "Who is the woman I want to be for my third act? What is it I want to do?" Really, I want to put my voice, knowledge, experience and connections at the service of other women.

All women are strong. I have never met a woman who isn't strong. Very often, a brother, father, husband, religion or even the woman herself will silence that strength. But when tragedy hits, she steps up. We are strong and we have power—once we realize that, we can use it.

DIANE VON FURSTENBERG is a fashion designer and chairwoman of DVF Studios, who uses the power of her voice, brand, philanthropy and leadership to uplift women around the world.

BAHRAIN

ESRA'A AL SHAFEI

I COULD NO LONGER accept to live in a society where I was required to ask for permission to have an impact. For me, it was really important to question power. All the things that we wanted to do were not allowed, because the authorities felt like their power was being threatened. As young people, we wanted to come together and say that this region belongs to all of us. We want to live in a world that we are proud of. A world where we have a voice and can set our own agenda.

I founded a collection of digital platforms that amplify under-represented and marginalized voices, specifically in the Middle East. In my region, censorship is the norm, and that's unacceptable.

I didn't think about acquiring power. I just wanted to have a voice. Over time, I realized that having a voice was power. Every time we document an abuse, we are giving voice. And repressive regimes feel threatened by multiplying voices.

> Sometimes, merely existing is power, as it is for the LGBTQ community. Just saying "we are here" is power. Simply being who you are is powerful. I think people tend to underestimate that.

I think being from a marginalized group makes you more empathetic. You understand the pain and trauma of persecution. You understand what's at stake, and that makes you more persistent. It gives you the patience that many other people don't have. I think persistence, even under the harshest circumstance, is the key to meaningful progress. It's how I overcome resistance.

ESRA'A AL SHAFEI is a social entrepreneur and human rights leader.
She is the founder of Majal, a collection of groundbreaking digital platforms.

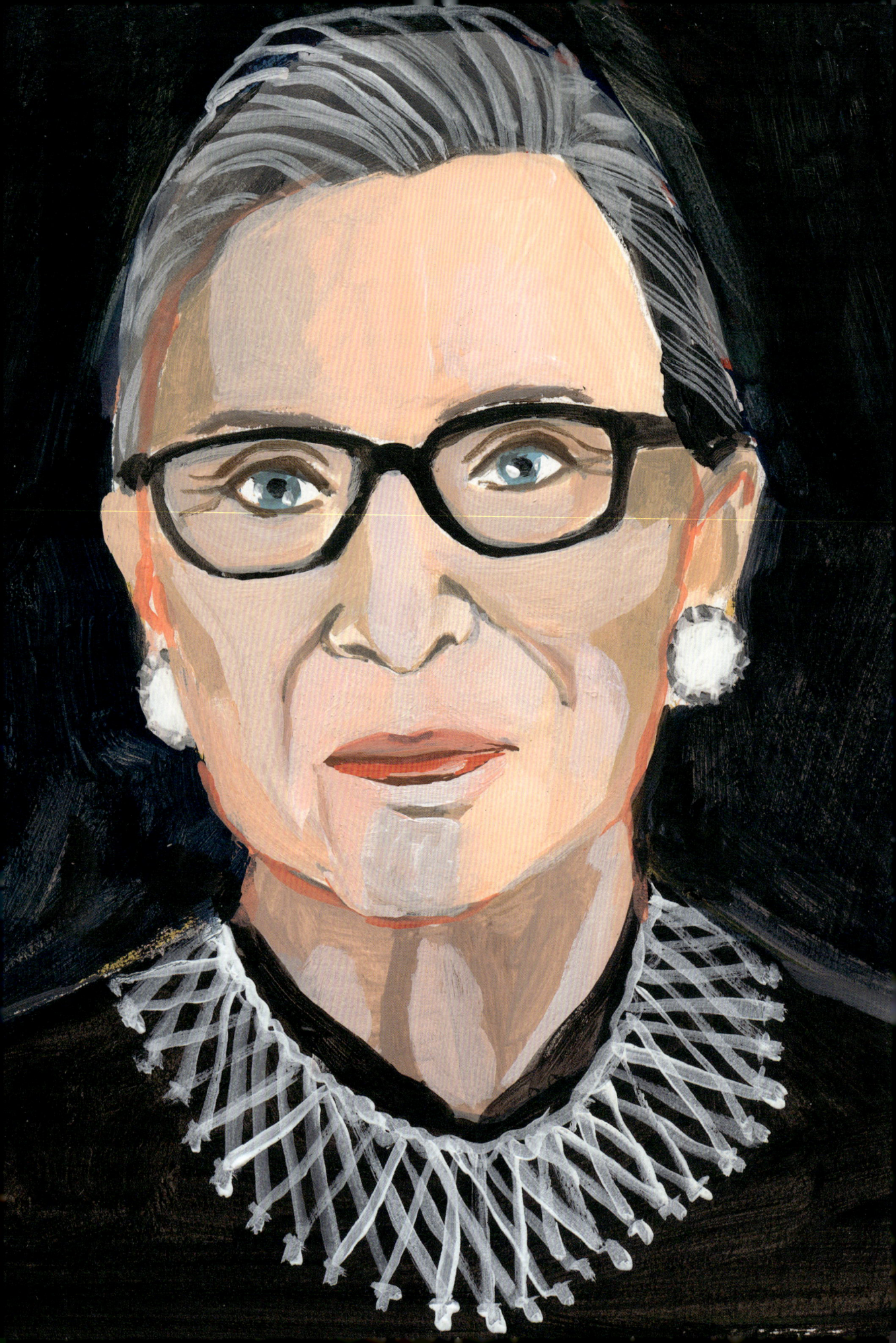

THE UNITED STATES

JUSTICE RUTH BADER GINSBURG

WOMEN BELONG in all places where decisions are being made... It shouldn't be that women are the exception.

RUTH BADER GINSBURG is the second woman in history to be appointed a U.S. Supreme Court justice, founder of the ACLU project on women's rights, and a lifetime advocate for the rights of women and marginalized communities.

EL SALVADOR

ARIELA SUSTER

WE CAN CHOOSE to be victims of the pain we experience in life, or we can harness that power to create change. I found a way to turn my pain into power, and created a social business that's disrupting the cycle of violence by employing at-risk youth.

I think we need to take out the word "help" and think of a different word that defines what we do. Because one of the things that creates change is not having any division, not seeing yourself as different from the people you're trying to make change with.

Old models of aid have been shattered. You can no longer go into a community and assume that you know what people need or want. Now, it's about listening and collaboration. It's saying, let's create change together.

At first, a lot of people who were close to me just didn't understand. I think I had to find that vision myself before I could put it out in the world and have it be understood. Now, I know that following this path is my truth. And it's not easy and it won't be easy, but at least now I know. I've learned to be resilient. For me, it's become about flexibility and being willing to change and to iterate.

I used to see power as something external. I used to think that the more recognition you had, the more power you had. But now it's shifted so much for me. Power is finding your voice, your inner unique strengths. Knowing that whatever is inside of you can affect the world outside—that has more power than anything.

ARIELA SUSTER is healing communities through opportunities as founder of design company Sequence.

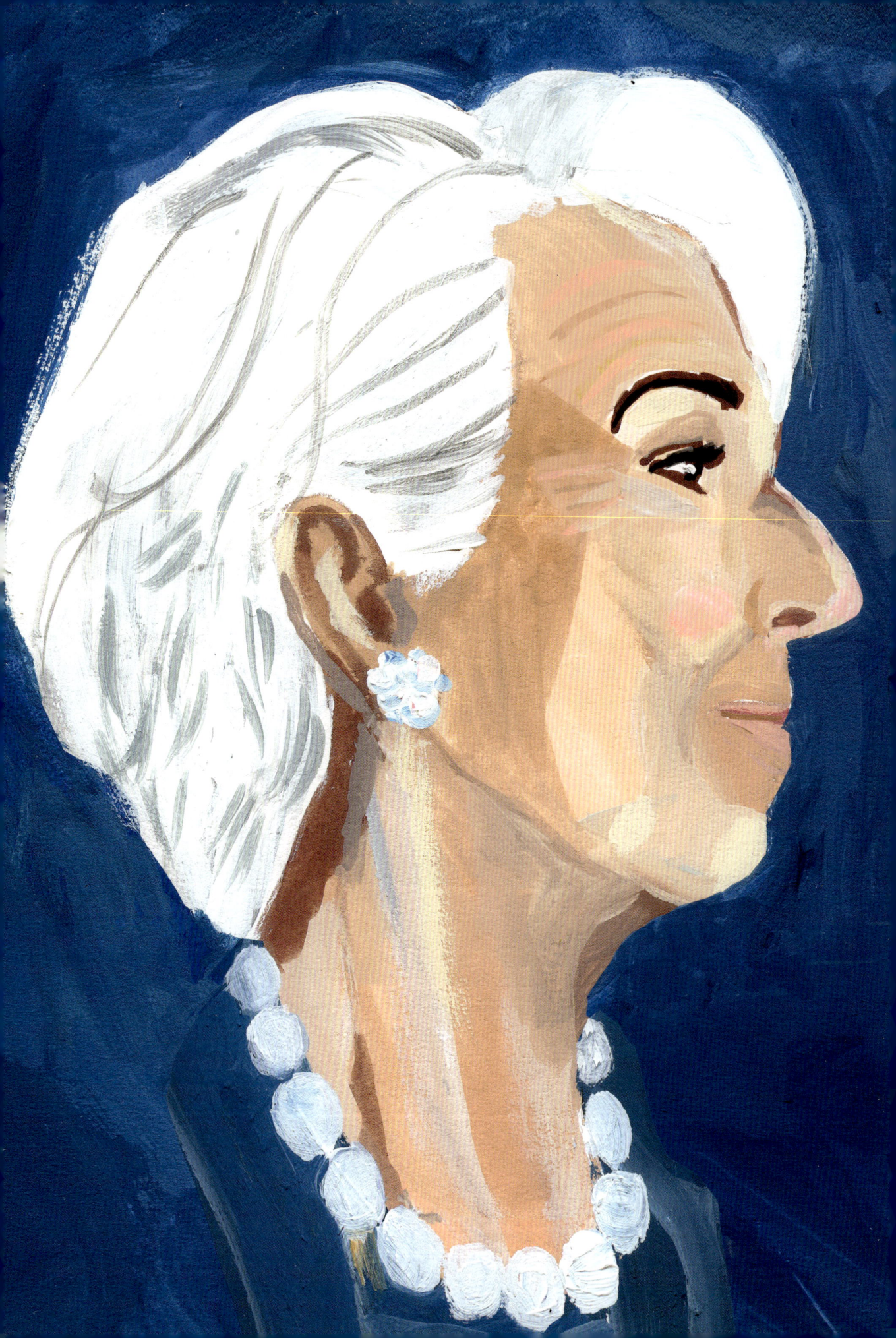

FRANCE

CHRISTINE LAGARDE

REAL CHANGE must begin with attitudes. We need to put an end to the idea that toughness flows from testosterone, and that toughness is top.

When I applied for a job with the largest, most prestigious law firm in Paris, I was fully equipped with all the skills and had taken the exams and was a fully qualified person. In my interview, I asked, "Will I become a partner in your firm?" They looked at me with a smile and they said, "Of course not." And I said, "Well, why is that?" And they said, with a bigger smile, "Well, because you're a woman." So I packed up myself, took my resume and left.

We know that women are more inclined to make decisions based on consensus-building, inclusion, compassion, and focus on long-term sustainability. They draw from deep wells of wisdom and tenacity.

Too many women are unaccounted for, underutilized, and over-exploited. It's a moral imperative, but it's also an economic imperative, to ensure that all women have the chance to fulfill their potential. The evidence is plain: When women contribute more, the economy does better. When women do well, society does better.

If you're in leadership for yourself, it's only going to take you so far. Make sure that there are other, younger women that are also coming up in the ranks, so that the day you stop, they also have space.

When you have what I call "corridor thinking"—everybody thinking the same way, having gone to the same schools, having the same impulse, the same attitudes — you end up with decisions that are never questioned, and it produces the results we've seen. More diversity is in order, more women at all levels of our societies and our economies. Please!!!!

CHRISTINE LAGARDE is president of the European Central Bank, and former chair and managing director of the International Monetary Fund.

GHANA & THE UNITED STATES

JOY BUOLAMWINI

I WAS WORKING on a set of art projects—and one particular installation needed face-tracking technology. And what I found was, the software available to me didn't work well on me until I literally wore a white mask. To see that my face did not fit the norm, or, rather, that a white mask was more the norm than I was, was a pivotal moment for me.

We were supposed to be at the forefront of what's next with technology, and then to be confronted with exclusion in a way that I hadn't expected—putting a white mask into the scene, and so erasing who I was to conform into a norm that's not reflective of me. What has been conditioned, to be seen as viable and to be visible, was what piqued my interest in learning more about why I was having this experience.

Part of why I started the Algorithmic Justice League was to sound the alarm, but also to say, "What is the alternative way?" We don't believe in naming a shaming. We believe in naming and changing. We say, "Here are ways to address the issue so that we can actually realize the promises of AI without succumbing to the perils." So it's not to say AI is good or bad. It's to say, "What kind of AI systems enable the societies we want?"

The progress we made for civil rights, women's rights, disability rights—so many people put themselves on the line so that there can be a more equal society and it's still a work in progress. If we do nothing, all the progress we've made can be erased under the guise of machine neutrality. So, now, I don't have to have the racist hiring manager, you can put the algorithm there instead.

JOY BUOLAMWINI is the founder of Algorithmic Justice League, a digital activist and a computer scientist who's on the vanguard of a movement to make artificial intelligence equitable and accountable.

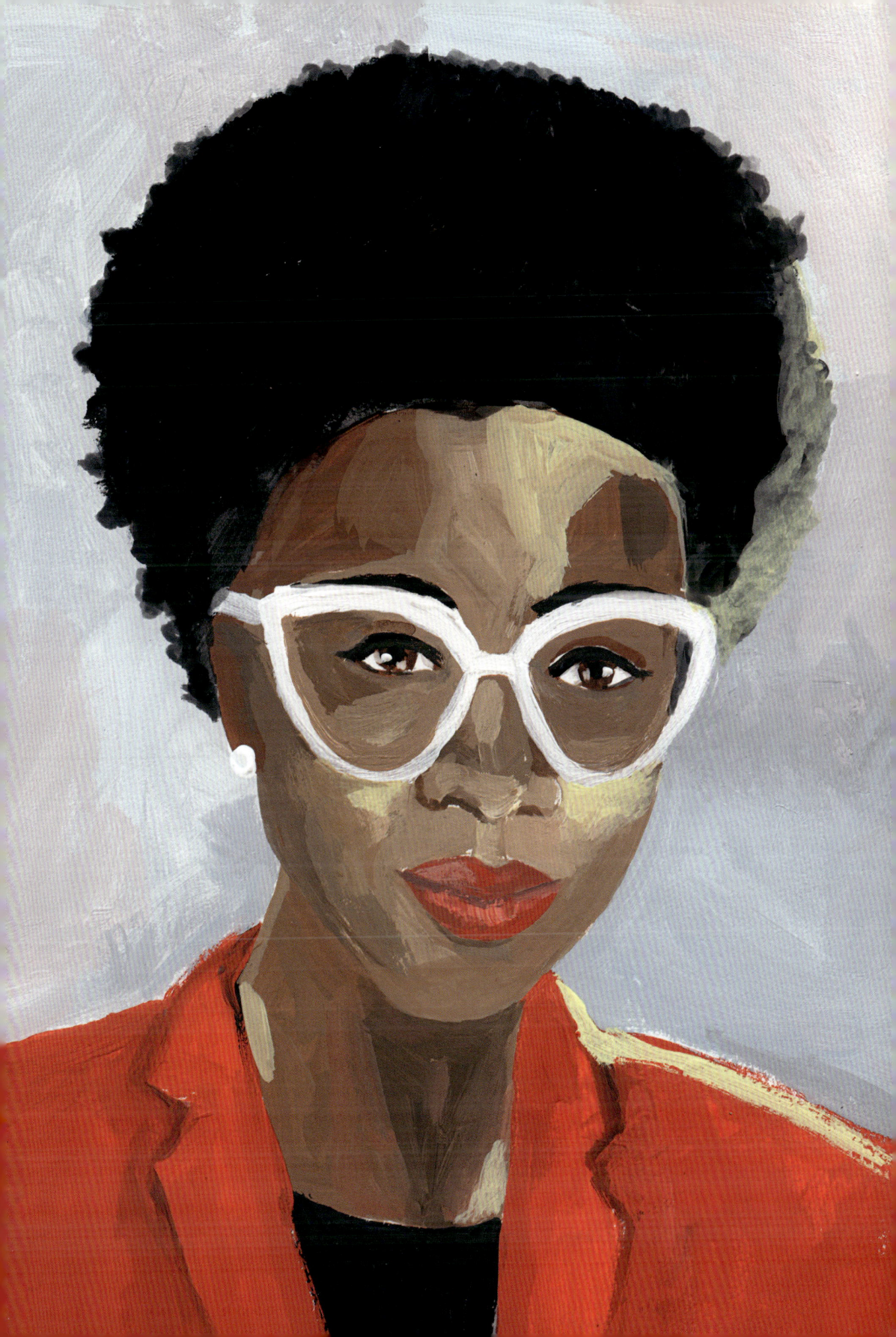

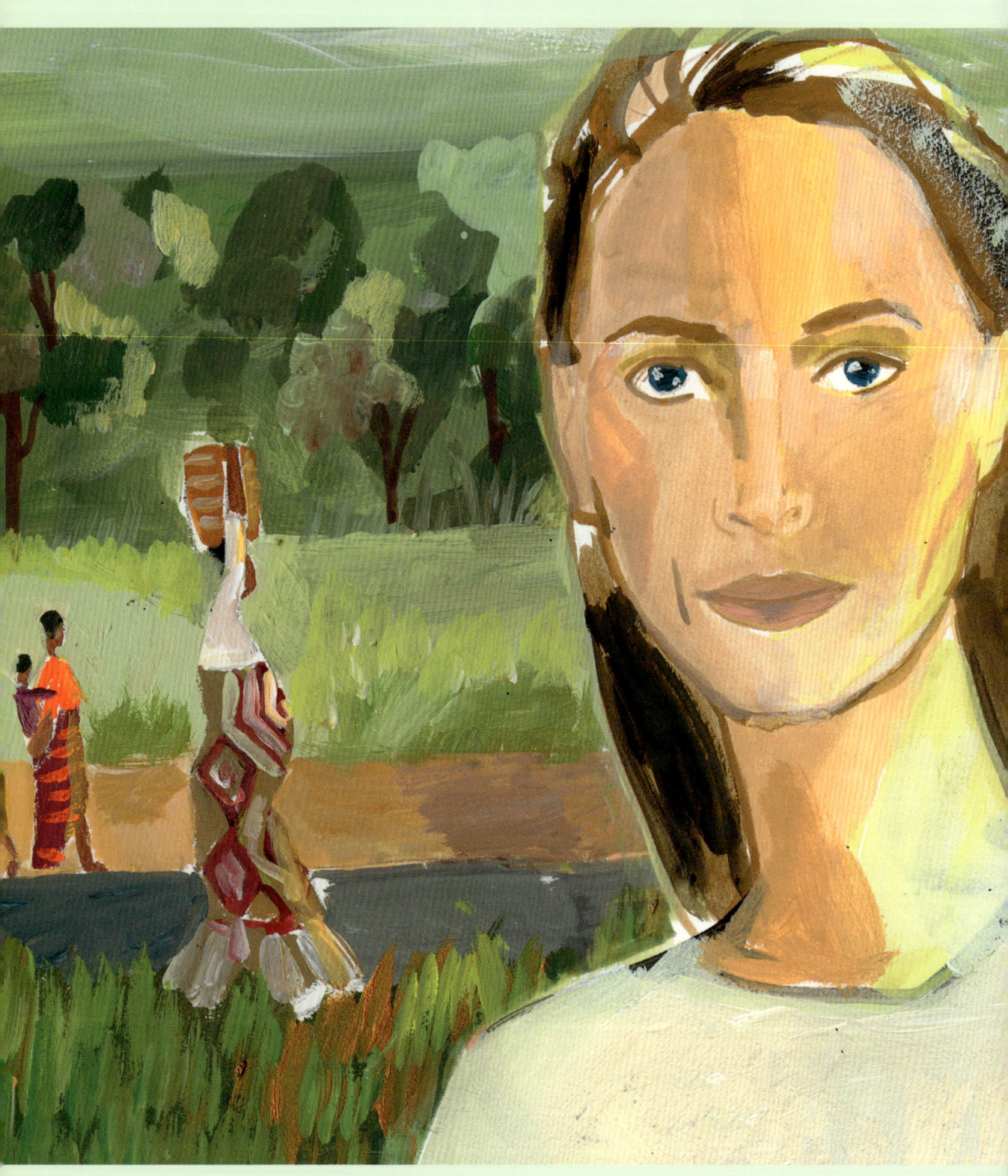

THE UNITED STATES

CHRISTY TURLINGTON BURNS

WHEN I BECAME A MOM IN 2003, never would I have imagined where that journey would lead me. That day, I learned just how critical it was to have birth options, resources and of course access to quality and respectful maternity care. Had I not had all of those things, I may not be here today. For me, it wasn't enough that I survived the postpartum complication after the birth of my daughter, the experience connected me in some way to every mother, everywhere. Once I learned about the half million women and girls who were dying from complications related to pregnancy and childbirth around the world each year, I had to do something about it.

The commitment I made to myself, and all the mothers-to-be, then, led me to become the global maternal health advocate I am today. I studied public health and traveled around the world, and made a documentary film of all that I learned and the women I met who shared their harrowing stories and lived to tell them. It was for them, their sisters and my own daughter that I founded Every Mother Counts.

Today, I still lose sleep knowing some women's lives are considered more valuable than others, and you don't need to look far to see the disparities. But I firmly believe that if we prioritize the lives of all mothers—not just some—around the world, we can make motherhood a safe choice and an experience not just to survive, but to thrive in.

CHRISTY TURLINGTON BURNS is a model, filmmaker and founder of Every Mother Counts, a nonprofit that works to make childbirth safe for women everywhere.

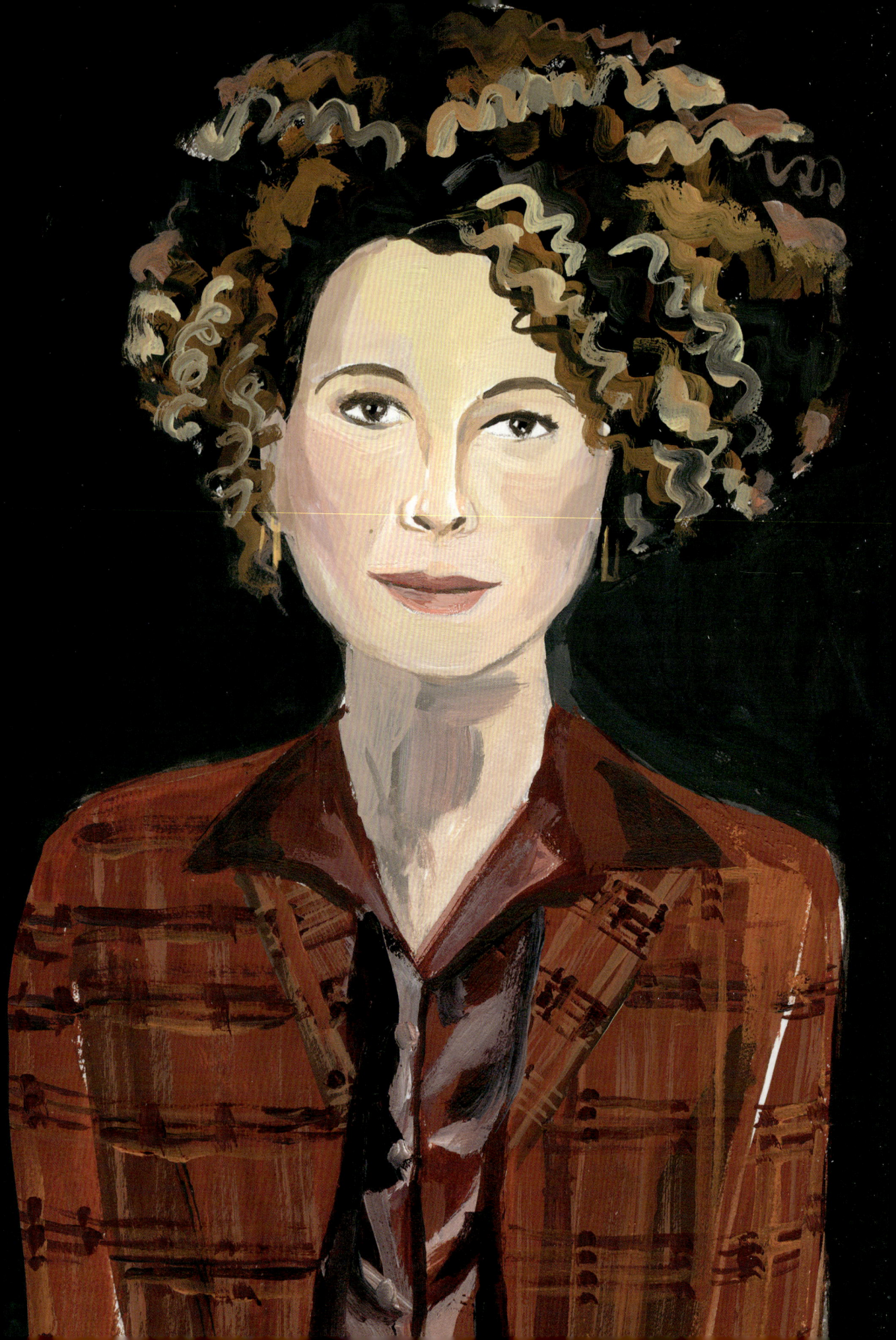

THE UNITED STATES & THE UNITED KINGDOM

DONNA LANGLEY

WHEN YOU HAVE A PLATFORM and the ability to communicate to a lot of people, that's power. When it goes unchecked by responsibility, accountability, and, most importantly, empathy, then it becomes an abuse of power. But if you add those elements, suddenly, the power equation becomes constructive and productive.

As one of the few female leaders in my industry, I'm fortunate enough to stand around a decision-making table, and with this privilege comes a responsibility and a need for empathy.

I see the most impact with the generation now entering today's workforce. A great filmmaker was giving a speech to college students recently and she said, "You're always asking me how to navigate this male-dominated industry… but don't ask me, because we didn't get it right." I was struck by just how right she was. This younger generation is getting it right. They're incredibly open to talking about and identifying solutions for some of the more complex issues and they're not interested in working in toxic environments. There's still a long way to go, but I'm quite encouraged.

I proudly come to work every day in a storied place, and it's been exciting to be part of a movement that is a new form of leadership. Years ago, you couldn't talk empathy, because it would have been equated to being weak. Being part of a group of incredible women is something that I'm very proud of, and I can't wait to have a front seat as this next generation takes their seat at the table.

DAME DONNA LANGLEY, OBE has been recognized as one of the most powerful women in the world and is chairman of the Universal Filmed Entertainment Group.

KENYA

KAKENYA NTAIYA

I WAS NEVER TRYING TO GET POWER; I was just trying to make a change. At first, a lot of people hadn't seen a woman do anything like this. A woman building a school for girls was really incomprehensible for many men.

We have shown that if you educate girls, their future is bright. People can see now what an educated woman looks like—and they like it. This mind-shift in the community is huge. Everyone is now excited about girls' education.

In ten years, we have educated and empowered over five hundred girls at our schools, and placed forty-eight young women into colleges around the world. We have also reached fourteen thousand boys and girls in our Health and Leadership Trainings. We teach that leadership is about knowing your rights and demanding them.

Culture has been there forever. Someone doesn't know what the other side looks like until you actually show them. They would think there is no way a girl could do that. Being able to show the results has been so valuable. If you show someone something, they can't walk away from it.

I was talking to my girls and I said, "If each one of us decided to do something, we could make the world a completely different place." I said that in front of the fathers and mothers. Suddenly, the fathers said "Wow, this is a movement that is being unleashed."

KAKENYA NTAIYA is founder and president of the Kakenya Center for Excellence, an organization committed to ensuring that every girl in her community has the opportunity for a different future, armed with education and free from violence.

INDIA

MENAKA GURUSWAMY & ARUNDHATI KATJU

AS WOMEN, IT'S IMPORTANT to take seriously this feeling of being deeply perturbed by something that's discriminatory and hence deeply offensive. It's also imperative to strategically think through the process of undoing the discriminatory law or policy.

One of the invaluable returns of being a lawyer is when something offends you, or when you're pissed off about something, you have a skill set that actually helps you address that situation of oppression—you can do something to make things right.

It was really difficult in those days to get gay people to step forward. You had a recently upheld sodomy law that punished you with ten years minimum, to life. There's stigma and there's loss of reputation, all kinds of things; but we were able to get on board some remarkable people who were willing to challenge this law.

In some cases, the Supreme Court is not just passing judgment in legal terms, but also in ethical or moral terms: It's sort of setting out a vision of what kind of society the Constitution envisions. So, having this judgment say that LGBT people would be embraced by the law and be included this constitutional vision of society, was hugely important for LGBT people and their families, including their parents.

If you are a woman involved in the law, then chances are that you are a minority to start with, because the law is a fairly male-dominated profession in India and elsewhere. I think that makes you persist, and you persist because you love what you do. But you're also tough, because you know that if you're not, you will not stay the course.

MENAKA GURUSWAMY & ARUNDHATI KATJU are advocates at the Supreme Court of India. Together, they became beacons of hope for the LGBTQAI+ community, in the world's largest democracy.

VIETNAM

MAI KHÔI

I USED TO BE A POP STAR. Now I am an independent artist. I am independent from the government and independent from a party. I am independent from all organizations and companies. I am my own person.

I do not know from where, or from what, I sing these songs, apart from emotional experience, because I'm an artist. I just feel like artists have a mission in life to express the truth.

We've lived in fear for a long time, and I know my parents are very scared about what I'm doing now. However, people in society hide their emotions very well. They don't tell the truth. I don't believe that is the right way to live. I just encourage my parents by telling them that what I'm doing now is not illegal because I know many people are following me. I'm well known in my country, and I want to change something for my country. I encourage people to step out of the fear and feel free to speak and to do what they want, like me.

Instead of writing articles or poems, I write songs. In this moment, what I feel, what I see, what I understand—I will write it down and sing it loud. We need to work with other artists and musicians to make art stronger, and expressed as powerfully as possible.

I want to practice the right of free expression in Vietnam rather than just talking about the need for freedom of expression. Through a little protest and the violent reactions of the authorities, I showed the world that Vietnam does not have freedom of expression. My protest also is a way of resistance against social norms that restrict freedom of expression.

MAI KHÔI is a Vietnamese singer and political activist who uses her platform to call attention to her country's human rights abuses and the oppression of marginalized communities.

THE UNITED STATES

HILLARY RODHAM CLINTON

"I BELIEVE THAT, ON THE EVE OF A NEW MILLENNIUM, it is time for us to break our silence. It is time for us to say here in Beijing, and the world to hear, that it is no longer acceptable to discuss women's rights as separate from human rights... If there is one message that echoes forth from this conference, it is that human rights are women's rights. And women's rights are human rights, once and for all." - **United Nations Fourth World Conference on Women Beijing, China, 1995**

THERE IS A LONG, long history of trying to silence women. Even today, women who speak out, speak up, or seek positions of power and influence face a very real challenge. How many times have we witnessed the all-too-familiar criticism of women's voices and the dismissal of women's ideas that reveal deep biases and dangerous beliefs?

What inspires me is the fact that, everywhere I go, I meet women who persist anyway. To these brave women, and to women everywhere: Do not be intimidated or bullied into not speaking. Do not grow weary. Take heart, know that you are not alone, and know that you are changing things not only for yourself, but for those who will come after you. Stick to your own truth, stick to your own path, and don't let people knock you off of it.

Throughout my life and career, whether I have meant to or not, I have challenged assumptions about women. I make some people uncomfortable. (I'm well aware of that!) But that's just part of coming to grips with what I believe is still one of the most important pieces of unfinished business in human history: empowering women to stand up for themselves, and for one another.

There cannot be true democracy until women's voices are heard. There cannot be true democracy until women have autonomy in their own lives. There cannot be true democracy until all citizens are able to participate fully in the lives of their country and our world.

HILLARY RODHAM CLINTON is a former secretary of state, U.S. senator and first lady of the United States. She used her power of platform to speak out on behalf of women and girls at the United Nations Fourth World Conference on Women in Beijing, China, in 1995, which sparked a global movement for women's empowerment.

SWEDEN

GRETA THUNBERG

I DON'T GIVE SPEECHES so that I in some magical way will talk world leaders into realizing that I am right and they are wrong. My long-term goal is that the gap between what science is saying and what is actually being done is made so clear that it can no longer be ignored.

GRETA THUNBERG is a climate activist who founded the global movement, Fridays for Future.

SKOLSTREJK FÖR KLIMATET

PAKISTAN

SAMAR MINALLAH KHAN

WITH TIME, I realized my anger wasn't helping me; so, I had to completely change my strategy. In order to address resistance, I had to just sit and listen to people who were resisting my mindset or what I was showing in my films. That's where my background in anthropology really helped, because we're trained not to judge people, but to just listen, experience and understand where they are coming from. That listening helped me make new alliances.

Even in Pakistan, if you're living in a city, you don't know what's happening in rural areas. I had to step out of my comfort zone to understand how and why certain harmful traditions and culturally sanctioned forms of violence against women and girls were taking place. I wanted to experience it with my own camera. I wanted to hear the women and girls myself.

I think that when I realized that a film has the power to change people's mindsets, that in itself was a very empowering feeling—to realize that film can not only move people, but it can move us into action.

I've evolved as a leader. I've become more patient, and I've realized that the more love I give to my work, the more comes out of it. Instead of starting off with fear—which was always there and which will always remain because of the kind of issues I work on—I've realized that when I turn that feeling into positivity, into envisioning what can actually come out of the steps I'm taking, it completely changes my entire outlook and the way I lead.

SAMAR MINALLAH KHAN is an anthropologist-turned-filmmaker-turned-human rights defender.

CHINA

GUO JIANMEI

IN CHINA, gender discrimination is deeply rooted, and the rule of law is relatively underdeveloped. Against such a backdrop, my colleagues and I face the realities head-on. Through our efforts to explain laws via case studies and to influence society via public interest litigation, little by little, we gradually change the conceptions concerning discrimination in our society and culture, which in turn helps gender issues to become mainstream.

In the past twenty-four years, the NGO that I founded has established a unique public interest legal-aid model for civil society, that encompasses women's rights, legal aid and NGO development.

We try to absorb like-minded people into our orbit. We don't fight alone. Collaboration can form a unifying force.

The core meaning and nature of power should be that it is used to protect the vulnerable in society, to uphold fairness and justice, and to help build a wonderful place that everyone yearns for. It should not be used to bully the disadvantaged or to protect those in power.

I don't think that what's really at stake is whether women lead differently from men; I believe the real issue is the conception of gender equality. For a male or female leader, whether the way they lead accords with the true meaning of equality depends on their own conceptualization and their practical abilities. To achieve equality, it is important that one undergoes continuing training so that this constant learning process renders self-improvement possible.

GUO JIANMEI is executive director of the Women's Legal Research and Service Center, of the law school of Beijing University. A pioneering advocate or women's rights, she also helped establish China's first legal aid clinic dedicated solely to women.

THE UNITED STATES

AMANDA GORMAN

GROWING UP, I had a speech impediment. Some words were garbled, and some letters were harder to pronounce. It took me years to figure out how to say some things. It resulted in this intense feeling of fear when it came to me wanting to speak up. I found an immense amount of freedom in writing my ideas down, because it gave me the liberty to express my ideas.

Often, what we consider our weaknesses are our superpowers. For example, when I was little, my speech impediment was my greatest shame, but now, my voice is its own anthem and source of power.

I think that we're seeing a form of feminism that is much more expansive than it has been historically—now we are demanding that voices that have been treated as marginal be at the focal point of the conversation. If we're actually looking to make revolutionary change, then we have to look at the intersectional systems that have chained us in the first place. Thinking about what connects us, not on a singular voice, is a much more powerful approach to social transformation

I think that as a Gen Z'er, I am living in an exciting time. **We have a profound imagination for the future. We can imagine a world where anyone can make a difference. I think the greatest power of Gen Z is the power to imagine.**

AMANDA GORMAN is America's first Youth Poet Laureate, and uses her art to advocate for equality.

MEXICO

SASKIA NIÑO DE RIVERA

WHEN I ASK FOR COMPASSION, some people can't really get their head around it. They have all this fury, and they don't know where to channel it. That's one of my biggest issues. How do I get people to understand the importance of creating a society where everyone is included—even people in prison?

I think the real change lies in the roots. We first have to understand the stories behind people in prison. We have to understand what caused them to commit crimes, before we can talk about prevention. I can understand people's hatred and anger; but my question is, "Why don't we try to understand the roots of crimes, the roots of oppression?"

I think that we have a lot of people in power who are insecure. And that is perverting power. Narcissism has no place in power. We have seen it in history, and we see it today. **We have to redefine power as a collective thing.**

I worry that we are heading in the wrong direction. We need to rethink how we connect as people. I think we are losing connection through technology and globalization. We're coming into ourselves and only worrying about ourselves. We're not able to look at the big picture. I think that what we're doing in our work with compassion should help us change how we connect with each other. I think that's going to be decisive on how the world is going to change. Are we going to connect or just be individuals? I really hope we can connect as human beings again.

SASKIA NIÑO DE RIVERA is the co-founder and president of Reinserta, which works towards creating a safer Mexico by transforming its prison system, and reintegrating young offenders and children who are born and raised behind bars.

CHILE

MICHELLE BACHELET

From time immemorial, discrimination and biased narratives have kept women from participating in the public sphere and from exercising their equal rights.

But universal, inalienable rights and freedoms cannot be forever taken hostage by so-called traditional gender roles.

The rallying cry "women's rights are human rights!" soon led to a milestone whose twenty-fifth anniversary we commemorate this year: the adoption of the Beijing Declaration and Platform for Action, when governments across the world acknowledged women have the same rights as men.

As the United Nations' high commissioner for human rights, as a former head of state and government, as a lifelong feminist, and as a mother and grandmother, I cherish the progress achieved since that meeting in Beijing; but I also recognize that we are nowhere near where we should be. From equality in political life and the economy, to harmful practices and gender-based violence, women's rights are under attack on many fronts.

It is not just women who pay the price for discrimination. Whether we are talking about fighting a pandemic, negotiating peace or driving business innovation, the whole world suffers without the full contributions of half its population. The 2030 Agenda for Sustainable Development recognizes that gender equality is indispensable for building a better future for all. A future with inclusive societies and strong democracies, resilient and sustainable economies, a healthy planet and enduring peace.

From an early age, I have learned the incalculable value of freedom, democracy and respect for human rights.

We must continue to push forward. Individually, and together, we need to resist all challenges to the hard-won affirmation of what we know: that women's rights are human rights—and that all human beings must be able to enjoy their human rights on equal footing.

Human dignity cannot be dissected, compartmentalized, negotiated—nor it can never be a privilege of few. Every violation of someone's human rights threatens the rights of all. And with more women exercise power—in the economy, in politics and across society—we will increasingly have the power to change power itself. For the good of us all and future generations.

MICHELLE BACHELET has dedicated her life to achieving equality and human rights for all as a public servant, at the United Nations and as Chile's first female president.

MALAWI

CHIEF THERESA KACHINDAMOTO

MY OPPONENTS here say I am defying our traditional culture. But in my view, we are redefining it.

Now, more and more male chiefs and village headmen are coming to me to say they realize the old ways are bad. They come to my district to learn about what I am doing. They want to know how to improve the lives of girls. They see what we are doing, and they take it back to their people. And they tell me things are changing now.

Growing up as a chief's daughter, I realized I had been shielded from how people in our villages really lived. I had to act. I could not allow mistreated and uneducated girls under my rule.

It is good that the law is on our side now, but enforcing it remains a big challenge. In many areas people still believe a girl is ready to have sex and babies when she reaches puberty. We have to eradicate these old ways of thinking.

Changing people's mind and views is not easy. You need to be strong whether you're a man or a woman. Young women who are considering entering the policy space should not expect quick or easy results. They must stick to the truth and think about the benefit to future generations.

Some have threatened me, saying things like, "You are still quite young. Are you ready to die?" But I just tell them to go ahead and kill me, because it is the only way they will stop me from protecting our girls. I want to give girls opportunity and freedom. When girls are educated, everything is possible.

CHIEF THERESA KACHINDAMOTO is chief of Dedza District in Malawi, and is singlehandedly reversing harmful cultural practices, such as child marriage.

UNITED ARAB EMIRATES

SHEIKHA LUBNA AL QASIMI

ONE TRAIT I BELIEVE IS ESSENTIAL for women leaders is consistency. Keep believing in the magic you're creating, move forward and face the obstacles that you encounter with patience and intelligence and, believe me, you will achieve your dreams.

Regardless of where you are in your career or which career path you choose to follow, the most important lesson I would hope for other women to remember is to stay true to your values, no matter the circumstances.

When I was appointed the first woman minister, I aimed to ensure that there would come a time when there would be so many of them that my presence would not be required. That time came when I stepped down. My job was to build a bridge, and I did that. It is unfair for any woman to sit in a job and not be there for the young ones. Our job is to leave a legacy, and the best legacy you can leave are people who become leaders themselves.

In my personal belief, you need a bridge, you need a door opener for women; and sometimes, women do not want to take the risk. Sometimes, they are shy of achieving what they should be achieving. I had the opportunity and I had the trust from the government and the community, so to me it is setting an example internally for the young women, and men, by the way.

There has been a rise in populism and hate speech. Values have started to erode worldwide. We have to remind ourselves that societies cannot exist on just moving forward without preserving our values, which are our assets.

SHEIKHA LUBNA AL QASIMI is the first woman to hold a ministerial in the United Arab Emirates, and is one of the most powerful women in the world. She has also served as minister of tolerance as well as minister of the country's economy.

THE UNITED STATES

MEGAN RAPINOE

T HERE'S BEEN SO MUCH CONTENTION in these last years. I've been a victim of that. I've been a perpetrator of that. But it's time to come together. This is my charge to everyone: We have to do better. We have to love more, hate less. We've got to listen more, and talk less. We've got to know that this is everybody's responsibility. Every single person.

I feel like we live in this scarcity-type culture. That's not the world I want to live in. I think we can move on from losing alone to the belief in winning together.

My mom impressed upon me at a very young age: "You ain't shit 'cause you're good at sports. You ain't shit 'cause you're popular. You're gonna be a good person. You're gonna be kind. And you're gonna do the right thing. You're gonna stand up for yourself, always. And you're damn sure going to stand up for other people. Always."

I think female athletes in general are at the forefront of every protest because we're gay, we're women, we're women of color, we're sort of everything all at one time. We're, unfortunately, constantly being oppressed in some sort of way. So, I feel like us just being athletes, us just being at the pinnacle of our game is kind of a protest in a way and is sort of defiant in and of itself.

You deserve the space that you can take up. And you can take up as much space as you need.

MEGAN RAPINOE is a professional U.S. Soccer player who uses the power of her celebrity to fight for pay equity and the rights of LGBTQIA+.

NEW ZEALAND

JACINDA ARDERN

One of the criticisms I've faced over the years is that I'm not aggressive enough or assertive enough, or maybe somehow, because I'm empathetic, it means I'm weak. I totally rebel against that. I refuse to believe that you cannot be both compassionate and strong.

JACINDA ARDERN is the fortieth prime minister of New Zealand, whose powerful and authentic leadership style is an example to women around the world.

THE UNITED STATES

SALLIE KRAWCHECK

ABOUT THE MOST POWERFUL thing you can do to help a society and economy is get more money in the hands of women.

Women doing well helps us all. It helps blaze the trail for others; it helps provide role models; it can help close the gender gaps we all face. In a world where women recognize the power that they own—and where technology can upend the traditional rules of engagement—one woman winning doesn't mean another loses. We can all win together.

What we have been doing to push for gender equality is not enough. To make progress, we need a more active stance. To begin with, let's throw out a few closely held ideas that just aren't playing out. One: the belief that progress is inevitable. Two: that ground, once gained, is held. And three: I for one think we should get rid of "empowerment" as a defining word of feminism. It can't be about "empowerment" any longer. **To make real progress, it has to be about power—using and growing the power that we women already have.**

We need to advocate for other women. This means overcoming the old rules, under which women and people of color have historically been dismissed if they advocate for other women and people of color, respectively. We cannot allow this to be the case any longer.

I've taken a few public hits in my career, and I never hid the pain of it from my children. Nor did I hide the regrouping and rethinking that occurred after each one. After all, that process allowed me to re-emerge and go on to build a more impactful—and more engaging—career path than the one I had been knocked off of.

SALLIE KRAWCHEK is the CEO and co-founder of Ellevest, and a financial advisor who turned a thirty-year career as a leader on Wall Street into a global movement to empower women financially.

NICARAGUA

XIOMARA DIAZ

A FEW YEARS INTO MY BUSINESS, I witnessed exploitation. There was an older customer sitting with a girl in her school uniform and I realized there was something wrong. It quickly became evident that it was sexual exploitation. From that moment I started to act. I couldn't just sit still and do business in a city where clearly tourism was bringing this additional threat to girls.

One of the biggest challenges for me is bringing down barriers in a country where there's a lot of class difference. I try to bring everyone together no matter where they come from, it's something I resisted for a long time. I wouldn't say it's a finished accomplishment yet, but it's very present in my leadership style—breaking down the barriers that exist between classes.

Growing up, I saw power as negative, because of its abuse in Nicaragua. Even to this day, when I hear the word "power," I still have to consciously remember that everyone has power. It's power that allows us to provoke change, it can be positive, negative or not yet embraced.

> I think women lead differently. I don't think we are better, but we are capable of naturally connecting with our emotions, to be more aware and identify what is inherently wrong and empathize at deeper levels. I think this allows us to use power in a different way. And what's beautiful about it is that it's a leadership style that can be learned by everyone.

XIOMARA DIAZ is a social entrepreneur, and founder and owner of The Garden Café, promoting sustainable tourism, and UP Nicaragua, mentoring at-risk girls in Nicaragua.

BURMA

YIN MYO SU

WE HAVE TRAUMA from the past in my country. Too many people in power still have wounds from the past. If you were a political prisoner and you never healed and forgave those who wronged you, you will just continue that cycle. **We need a new kind of leadership. We need to listen, have compassion and empathy. We need to heal, trust and build anew.**

We were cut off from the world for sixty years. While capitalism matured in other places, we developed our own ways, however we could. With the things we had in our hands—our culture, our natural environment and, most importantly, our people. To me, those things are more precious than money. And so, the business model I have is one that includes them in my bottom line.

We talk about a big tree, hosting all the birds. But I don't trust in one big person to save the world. That just seems like a story, a story to allow a few people to become very rich while others get by on very little. I believe in collective success. I believe in many trees that create a forest.

If the future will be bright for many, we have to do business better. We must acknowledge the balance between opportunity and responsibility. The next generation will demand it from the businesses they support, and they will support businesses that invest in this way.

YIN MYO SUU is a conservationist, entrepreneur, and founder of Inle Heritage.

THE UNITED STATES

KAY BAILEY HUTCHISON

THERE ARE INCREASING NUMBERS of women in the highest levels of U.S. government. They are in the leadership in both houses of Congress, and the executive and judicial branches; they wield power. A large majority of women who run for elective office win. We would all like for it to go as fast as it can, but it certainly is going in the right direction.

I think women are consensus-builders. It is a trait that we have grown up with and are really comfortable with, because we're used to trying to get things done; negotiate a dispute, so both sides feel they have gained.

When I first ran for the state legislature, a woman still had to prove that she would do what she said she would do, and that she really could be effective in the position. By the time I retired as a U.S. senator, the increase in the number of women and the experience that we had gained really made it much more equitable; we were communicators; we were in leadership. We were accepted on a more equal basis. Our voice was heard on a more equal basis. While that wasn't necessarily the case when I was first elected, by the time I left, it was.

I always believed that once the elections were over, you had to make headway on your priorities. But in any legislative body, you're not going to get your way 100 percent of the time. I very much had democratic partners. You have to recognize that America is a diverse country, and therefore sends diverse senators and members of Congress with different views from yours. You have to work with them; communicate, negotiate and move forward. You win some, you lose some, while keeping good relations for the next time.

KAY BAILEY HUTCHISON is a Texan politician who shattered barriers to become Houston's first woman television news reporter and the first woman to represent Texas in the U.S. Senate. She is also the U.S. Ambassador to NATO.

CHAD

HINDOU OUMAROU IBRAHIM

I COME FROM AN INDIGENOUS COMMUNITY of nomadic pastoralists. We depend on the environment, so when we have land it is not only having the piece of land but having our traditional medicine, having our food, having our water and having our safeguard as a human being, depending on the earth. It's our life. **If this environment is not protected, that means our life is not protected, and vice versa—if our lives as indigenous people are not respected, if women are not respected, we cannot take care of this environment.**

As a woman you are already marginalized. But when you add indigenous and woman, you get double marginalization because your community is already a marginalized community. You have to fight to recognize your community and you have to fight to get recognized as a woman who is adding value not only in your community but in the entire world.

When natural resources start shrinking, it stops the community that used to live in harmony and now has to fight to get access to these resources. This issue does not allow them to be the man or the woman they used to be. These roles have changed now. Because if men cannot feed their families, they have few options: some of them choose to migrate Europe or big cities to find a job. Others can be tempted by the armed groups who offer them large amounts of money if they join them.

Now what we are fighting for is our lives but also the future generation. If we do not create a sense for them to stay in the community, for us, we are going to lose our identity; and when we lose our identity, we lose all our traditional knowledge and we lose belief in nature—that's what's currently happening in different countries.

HINDOU OUMAROU IBRAHIM is coordinator of the Association of Peul Women and Autochthonous Peoples of Chad, and works at the intersection of indigenous rights and climate justice.

AUSTRALIA

HANNAH GADSBY

TO BE RENDERED POWERLESS does not destroy your humanity: Your resilience is your humanity. The only people who lose their humanity are those who believe they have the right to render another human being powerless. They are the weak. To yield and not break, that is incredible strength.

HANNAH GADSBY is an Australian comedian and writer whose genre-bending approach challenges audiences to confront sexism, homophobia and misogyny.

PAKISTAN

ROSHANEH ZAFAR

M Y FIRST MENTOR was my grandmother, who, in her own right, was an icon. She was a musician and artist. She chose to live her life on her own terms. I remember she told me, **"If you are to do anything for the people of Pakistan, you must do it for the women."**

The ultimate vision is about economic equity. It's about economic rights. It's about women having economic voice at all levels, whether it's influencing the economy or their choices.

People would tell me, "This is not our culture, it's not going to work." But to the contrary, having spent time with women in Pakistan, in the field, I really had this sense that micro-finance can work.

Women who work with us are more confident in expressing themselves in family decision-making. Many times, they're deciding on the age of marriage for their daughters, which in Pakistan is a major issue. So, there is this shift happening, where economically engaged women see the potential of their daughters.

Now, there are families where women have been taking loans and investing in businesses for over a decade; so, their children have grown up knowing that this is how to get out of poverty—this is a solution. Women's involvement and participation in the household economy is a solution that can help us to move out; and so, it's a mindset change that's now happening.

ROSHANEH ZAFAR is founder and managing director of the Kashf Foundation, which uses a sustainable model of microfinance that puts women at the center.

INDIA

SUNITHA KRISHNAN

EVERY CHILD OR GIRL I rescue reminds me why I started what I am doing right now; the anger flushes me with the energy required to continue and sustain my mission, and the memories ensure that I will not stop. It is a daily battle of memories and mission-building.

It started because I was very angry, very outraged at the way the world treated me years back, when I was gang-raped. **There was a huge rage inside me that kind of got channeled into a very pure action to do something for people who are subjected to sex crimes, and women and girls who are sold into sex slavery.**

It was a very challenging time, where women in brothels were thrown out and evicted from their spaces and dumped inside the jail. I started my inroads into working with these women; and they said that the one thing that I could do was to do something for their children. So, they made a choice that this generation should not go through what they have gone through. And so, we began as an organization.

I think the fundamental thing is recognizing that each of us has a huge source of power within us, which needs to be tapped. We have the capacity under the layers of pain. There's a whole world of power that we can depend on—recognizing that, I think, has been one of the key factors in my life.

SUNITHA KRISHNAN is the co-founder of Prajwala and a fierce activist who combats commercial sexual exploitation in India by rescuing and rehabilitating women and children from brothels.

GUATEMALA

KARLA RUIZ COFIÑO

I THINK WE HAVE TO TEACH OUR KIDS to be good digital citizens. One thing that is very important is that we teach them how to have critical thinking. Not everything that they see online or in a movie, on Facebook, or on any mini-screen, is true. They need to develop this muscle in their brain, knowing how to sort things, what is true and what is not, what is good and what is bad; and they cannot do it alone. Parents have to interact with them and create a digital critical-thinking strategy.

I envision a community of change-makers that, connected through technology, can really improve the world. That's digital awareness.

What we do is teach people how to behave as positive digital citizens and inspire them to become digital leaders. When you become a digital leader, how are you going to harness the power of social media and digital strategies for bettering the world? **My mission is to recruit, inspire and empower people to become digitally aware so that we can create a future of interconnected global leaders who are keenly aware of the power they have and know how to use it.**

It's not just about having followers or hashtags or sharing things; let's go out and do real things. And for that, you need to build real and genuine relationships—and that takes time.

KARLA RUIZ COFIÑO is a digital strategist and social media specialist, entrepreneur, and advocate for women's leadership in Guatemala and beyond.

THE UNITED STATES

TARANA BURKE

FOR SURVIVORS, we often have to hold the truth of our experience. But now, we are all holding something, whether we want to or not. This accumulation of feelings that so many of us are feeling together across the globe is collective trauma. This is bigger than a moment—we are in a movement.

My vision for the "Me Too" movement is part of a collective vision to see a world free of sexual violence. I believe we can build that world. Full stop.

We reshape the imbalance of power by raising our voices against it in unison, by creating spaces that speak truth to power. We have to re-educate ourselves and our children to understand that power and privilege doesn't always have to destroy and take—it can be used to serve and build.

In my work, we strongly discourage victim language. Not only because psychologically it's more empowering to survive something than to fall victim to it, but because it pushes back on the false notion that we need or want sympathy or pity. We have already survived some of the worst things possible and we're still here. And so, we should be engaged from a place of power. We are a constituency, a power base, and we are no longer hiding in the shadows.

I could have never dreamed that I'd live to see a time where we were having sustained national dialogue about sexual violence in this country, but here we are. What this moment has solidified for me more than any other time in my life is that anything is possible. Even in these gloomy, untenable political times, I still feel like anything is possible.

TARANA BURKE is the founder of the "Me Too" movement.

AFGHANISTAN

ANDEISHA FARID

I AM SURE THAT EDUCATION changed my life. I grew up in a refugee camp; but I still consider myself one of the luckiest kids, because I received an education. It then made me want to use that knowledge to provide the same or even better opportunities for other kids, to change their life.

I received my education under the Taliban, when women's education was basically illegal. So, something good that happened to me, at the time, was not allowed. That really made me believe in the power of education.

I started with twenty children. And then it expanded to eleven orphanages. Now, the children who went through the program, they are graduates of universities, they're working in different sectors, running their own nonprofits.

Working in a country like Afghanistan, that's very misogynistic, it's not easy to simply provide education for women and girls; and that's been not only because of the Taliban, but due to some others that don't believe in women's progressive education in fields such as music, sports and technology. The pushback is from different parts of society.

Sustainability is really an issue—especially now, with the political climate. Just to receive an education, it's no easy feat. Every day, even walking to school is a big deal. I mean, anything could happen to them. Going to school, the girls could be attacked with acid.

I think women leaders in Afghanistan have been an example for the younger generation. They have been tremendous role models for young women in a very conservative society.

ANDEISHA FARID is founder and chair of the Afghan Child Education and Care Organization, a network of orphanages that provide education to Afghan children.

JORDAN

LINA KHALIFEH

IF YOU ARE TRYING TO MAKE A CHANGE in any society, you have to expect resistance. When you face resistance, it means you're making a change.

A lot of women think that they cannot achieve what men can achieve, simply because they were raised that way. But I am trying to teach women that impossible is just a word: They need to change the way they see themselves. This is not easy, however, and it takes time. I tell them that you can do whatever you want to do and be whoever you want to be.

There's a dark side and a good side to life. What I see in society is that we are only preparing kids to deal with the good stuff. But they cannot hope to understand who they are and how to be, if they are not also prepared for the dark stuff—for challenges that will happen. We need to prepare kids for both sides of life.

I focus on working with women and children from the inside to outside, because everything starts and ends with you. It's not just about physical training; it's about internal training.

It took me a long time to get to know who I am. Sometimes, you have to get alone in your head and find out who you are. People have to heal themselves and then heal the world. That's what I did. And then I realized I had this power inside of me, and I decided to use it to help people. I think I felt the most powerful after I got past thirty. I feel more balanced. Now I know that there is nothing I cannot do in life.

LINA KHALIFEH is the founder and owner of SheFighter,
a global movement for women to reclaim their power through self-defense.

FINLAND

SANNA MARIN

WE ALL HAVE TO FIGHT each and every day for equality, for a better life. It's very important for everyone to step in; it's not someone's else job. That is the reason why I got into politics.

SANNA MARIN is an environmentalist and the prime minister of Finland. She is currently the world's second-youngest head of state.

NIGERIA

HABIBA ALI

Y OU'LL MAINLY FIND THAT THE EFFECTS of environmental degradation impact women more than men. In northern Nigeria, one of the major problems we have is deforestation, causing lower water levels for rivers and wells so that women walk longer to get water, being the ones who undertake household activities, especially in rural communities, where fetching firewood is now a distant pastime, and all activities women undertake at the household level is increasing.

Women have immense power within, but the norm here is that a woman is born into a family and sheltered by her father, she gets married to continue being taken care of, by her husband, and this serves as the ideal situation. As a result, the woman does not realize she has a voice and can share her opinions or wants, and loses touch with her innate powers.

I firmly believe that giving the understanding to unearth and revel in the feminine power is part of my work. It is one of the best parts of my job, when I get to see a woman realize that she can harness her strength, step up, go out and have a voice—taking initiatives that catalyze meaningful and lasting change for humanity.

People say I am too idealistic, where I say, I want an equal world; in other words, let us have control over whatever situation we find ourselves in. Your reality should not be shaped by the fact that you are poor or a woman. **Whatever your reality is, let it be powered by you.**

HABIBA ALI is the founder, managing director and CEO of Sosai Renewable Energies, bridging the energy gap by bringing renewables to rural Nigeria.

93

IRAQ

NADIA MURAD

I'VE COME TO ACCEPT that it is natural to face resistance when you challenge the status quo. When I face criticism, hostility, and opposition, I think about my mother, my nieces, my brothers and the Yazidis who have lost their lives and who are still displaced—as well as women around the world who suffer sexual violence in silence—and I tell myself that I've come too far to give up.

Because I use my voice to amplify the voices of others—my community and women everywhere—I will never allow myself to be silenced.

It can be hard for marginalized people to come forward and speak about their experiences, but we should dismantle the hierarchy of voices that have silenced us for far too long. I tell my story with the hope that not only will people listen to me, but that they will feel inspired to share their narratives as well, and that we will be able to advocate together for real, lasting justice.

I think a tipping point will be reached when the diversity of the people in power reflects the diversity of the world that they are leading. Hopefully, when this happens, all peoples' voices will be equally represented and reflected in important decisions.

Being women in a patriarchal global society makes us empathetic to the plights of difference marginalized communities. I think that our ability to empathize with others is one of our greatest strengths. We try to listen to others because we know how it feels to be silenced. We understand discrimination and pain too well to want anything less than peace and justice for all.

NADIA MURAD is a Yazidi human rights activist, Nobel Peace laureate and founder of Nadia's Initiative.

INDIA

PRITI PATKAR

FOR ME, there was no particular moment that changed everything; instead, everything kept unfolding over a period of time.

I started this work because I witnessed an absence of rights for children in the red-light area. In the early days, my focus was on children born to prostituted women and the intergenerational cycle of prostitution that existed there. It was about disrupting this cycle, whereby children get to enjoy their lives and take back control of their own bodies.

I remember when the first proposal we wrote came back. It was filled with questions like, "Can you give us guarantees?" **And all we were trying to say, is, "I cannot give any kind of guarantee, I just know one thing: Every child, no matter where he or she is born, who they are born to, has a right to be protected, to access formal education, and to participate."** But it was so difficult to make people understand that.

I think encouragement is a continuous process, a journey. You have to be there to provide support, and to give and receive suggestions. It's about mentorship rather than criticism. You have to encourage people to take their own decisions. Decisions, sometimes, which may not work, but you need to be there for them and help them until it does.

I believe in a democratic way of working. I like to get people around a table and discuss things. I see them as allies and not as competitors. I believe that inclusion comes to us easier than it does to men.

PRITI PATKAR is co-founder and director of Prerana, an organization committed to ending the cycle of intergenerational sex abuse and human trafficking in the red-light district of Mumbai, India.

THE UNITED STATES

MELANNE VERVEER

AS FIRST LADY, Hillary Clinton didn't believe that being a symbol could be efficacious. Then, the Beijing women conference happened, and she realized she could help raise the vital voices of women the world over—women who were too often marginalized yet doing heroic work on the frontlines of change.

Everything began to change after Beijing. I think we lose sight in some ways, as time elapses or as knowledge isn't apparent. But this was a pivotal moment. Pivotal in many, many ways. And it certainly was one of those moments in terms of the impact on me.

One of the things that struck me the most was that whenever I would meet women—whether it was a minister or a change maker in their society—one of the first things that they would say is, "My name is so and so and I was in Beijing." And that part, "I was in Beijing," was to say, "I am with you. I understand we come from the same place. we're working on the same issues."

When I was growing up, there weren't very many women recognized as leaders in government, or in politics. That's why I feel so strongly about role models. When girls can see a female astronaut or a female secretary of state, when they can hopefully see a woman president of the United States—it changes everything. It makes everything possible for them.

The standard for a woman is so much greater. When a woman fails as president of her country, it's said, "Well, we tried a woman, it doesn't work." It doesn't matter that male presidents fail, and can fail regularly. She is the one who carries the scars, so to speak. Failed male leaders will continue to be elected. It's a totally different standard.

MELANNE VERVEER is the first U.S. ambassador for global women's issues,
co-founder of *Vital Voices* and a dedicated advocate for the advancement of women.

PAKISTAN

SHARMEEN OBAID-CHINOY

Growing up in Pakistan, I was always asking difficult questions from everyone around me. Questions no one wanted to answer. One morning, when I was about ten years old, my car had stopped at a traffic light, I was headed to school. I looked out of the window and saw a girl my age barefoot, nose pressed against my window, her hand stretched out, she was begging. That day at school, I asked everyone why that girl was not at school. Nobody really had an answer, except to say that is just the way the world is. I remember not being satisfied with the answers and thinking that everyone should have the opportunity to go to school.

I have always been a storyteller, I began writing from a young age and at the age of twenty-one, I moved into visual journalism and documentary film-making. **I've always believed that when you tell a story that evokes empathy in people, you have the opportunity to move the needle on the issue. I have found film to be a powerful medium, it has the ability to impact the way men see women, the way women see themselves and the way society perceives issues.**

I have been a social justice documentary filmmaker for the better part of two decades and my films have impacted legislation in Pakistan. In 2016, my film *A Girl in the River*, helped convince the prime minister that a loophole in the honor killing law had to be closed, thus ensuring that men who killed women in the name of honor would get life imprisonment.

Film, has the potential to literally save lives and in a country like Pakistan where there are high levels of illiteracy film can change norms and cultural patterns that bind women. In 2017, I developed a mobile cinema. A large truck outfitted with a screen that travels from village to village screening filming for men, women and children offering them insights into a world beyond theirs.

As the community gathers to watch films under the night sky, conversations ensue from child abuse to a woman's right to inheritance. Through these films, we are changing one mind at a time!

SHARMEEN OBAID-CHINOY is a Pakistani filmmaker and activist who uses journalism and film to tell stories of marginalized and disenfranchised communities.

GUATEMALA

MARIA PACHECO

IMAGINE A WORLD WITHOUT BORDERS, where everyone becomes a citizen of the same world. Instead of borders and me and you, it's us. I would love to live in a world with an appreciation of the talent that each culture and each person has—a world that gives opportunities for those talents to unfold.

I always say that **collective dreams are unstoppable**. When you're able to connect to others, to understand them and build something together, that's power. I think that power comes from really being able to connect to a person and share a common goal.

It's been a thirty-year journey of connecting communities to markets, of finding out how we can create value chains around things like planting trees and harvesting sustainable wood; or thinking about how we can connect people with these beautiful ancestral skills, to markets.

Things changed for me when I started to really value women's energy as something that we have to be proud of. It's unique to be a woman. It's a privilege that we get to see life the way we do. That we are able to lead the way we do. And I think that now, we're becoming more visible. And our energy keeps multiplying.

There's so much to do, I don't think about competition. I hope other people start businesses like mine. I think it's about being open, showcasing what we've done, and supporting others to act, too.

MARIA PACHECO is the founder of Wakami, a social enterprise connecting impoverished communities across Guatemala with markets, to transform people and the Earth.

CAMEROON

KAH WALLA

WE ARE NOT ASKING FOR PERMISSION. We don't ask if we can join. We don't ask if we're allowed. We show up. We occupy space. We take a stand on our position. In Cameroon, this is revolutionary in itself, in a political culture that is dominated by older men.

What we try and do is transform the discussion. Instead of focusing on individual politicians, we talk about fundamental rights; and then everyone has to react to that. I think this is really how we're transforming political culture in Cameroon.

I define power as simply me, you, us. We have to understand that there is no other place where power exists. All forms of power are in places where we have decided to delegate it. Whatever power anyone exercises, it's what we have allowed them to do. We need to be much more conscious of the power we have. We are power. What are we going to do with it?

For me, as an African woman, the key to transforming culture is to step into history. Our history as African women is not being taught. But when I started studying that history, I soon found all of these stories of African women who changed our societies and were considered revolutionary. They were building cities and ruling nations. So, when I talk to people, I always tell them that what I am doing is not new; African women have always been doing this. This is our place, and we don't have to ask for permission; we can simply step in and change society.

KAH WALLA is a business owner-turned-political leader who believes in the power of people.

THE UNITED KINGDOM

TINA BROWN

WOMEN ARE PLACED to be the major change makers in the next ten years because they are much more adept at refusing to lead by fear. They are no longer willing to hang back or worry about disrupting the status quo. They are inspired by each other. They're saying, "Why not me? I can be the one who creates change, who runs for office."

In a sense, digital disruption and social change have played to the strength of women. Women understand how to do multiple things at once because they have always had do. I feel strongly that women are finally not needing to apologize—they do not have to pretend to be a kind of "fake man in a role."

For so long, women have not been well represented. We only hear about celebrity women, somehow only women of the day. We weren't hearing the narratives of global women living behind the lines of the news, standing up to repression, fighting hate, and breaking down barriers. I thought, "How can we hear from them?" That's how Women in the World began.

In this world where maximum attention is given to matters that are absolutely not important, the voices of these heroic women matter. We started by putting these women on stage in a small, midtown hotel, but it felt important even the very first year. I see my role as an amplifier for these women.

TINA BROWN is CEO of Tina Brown Live Media and creator of Women in the World, which unearths and amplifies groundbreaking stories of women and girls from around the world.

SYRIA

AMANI BALLOUR

THE ONE THING that helps me is knowing that we were in the right, on the right side of history because we opposed the injustice. My conscience is clear.

I said no at the beginning. It was very dangerous for me to accept because the Assad regime and Russia were targeting hospitals. And I was the manager of the hospital and responsible for everything.

Men in our community, they say, "No, you should be at home, or you can work in your clinic, but not to be a manager of the hospital." I insist and I want to challenge them and prove that a woman can [do this work]. I have to support women because if I succeed, all women will be supported. That will make men think that of course women can succeed, and they can do that.

When I was a child, no one said to me that I have rights. No one said to me that I can be an important person in the future. So, I tell the children in the hospital, "You will survive and you have to think of the future. You can be a teacher, you can be a doctor." This is very important to me, because no one said that to me when I was a child.

> I can be a voice for the Syrian people who are now voiceless, and I am proud to be able to do that. I hope by being a voice, I can help others get to a safe place too.

There was no safe space. Imagine being the victim of an airstrike, you're treated in hospital, and them bombed there too. The hospital was hit many times. I've been asked to verify how many strikes. Believe me, I couldn't count them all.

DR. AMANI BALLOUR is a pediatrician who managed an underground hospital during the Syrian Civil War, and treated thousands of victims of airstrikes and chemical attacks.

UKRAINE

OKSANA HORBUNOVA

I WAS A PARTICIPANT OF TWO REVOLUTIONS in Ukraine, in 2004 and 2014. I met women like me on the streets who were there just to protect the dignity of the people and whole nation. Should we have more women in power, they would protect our dignity in more effective ways. We need laws to free the world from corruption and create peace opportunities. We need more women in power to do this.

My family taught me not to be indifferent, to be close to the people in difficult times and to help people. My mother was a starvation survivor during the Soviet regime. She was so strong. She trained me to be active and open and to help people.

We became the voices of the victims who were being kept silent. Women and girls were increasingly becoming victims of human trafficking. It was time to educate society. We started a hotline. We started to think about how we could use mass media to inform the public, and about mechanisms to protect victims of human trafficking.

I had a client in the early days of my work, a young girl who was trafficked when she was twelve years old. She was sold several times. I contacted a journalist and her story was published in the newspaper. It was like a bomb. Government officials accused me of spreading false information.

We have to be creative and proactive in our actions. The traffickers are working very creatively and have strong networks. There are no obstacles for them. Being a human rights activist, I have to work through the system. Collaboration and partnership with government and non-governmental activists, and between countries, has been critical. We have to build our own powerful networks if we have any hope of catching up, of beating this.

OKSANA HORBUNOVA is a Ukrainian activist who exposed human trafficking on a national scale in the 1990s and went on to create her country's first counter-trafficking organization, La Strada.

INDIA

ELSA MARIE D'SILVA

IT WAS A TRIGGER FOR MANY PEOPLE. After news of the gang rape, everyone around me had a story to share, but until then none of us had spoken about it. I was reminded of my own experiences and, reflecting on that, **I felt it was imperative to do something—something concrete that would make a difference.**

All I could find was data from the UN. But it seemed like everyone was experiencing harassment, so clearly the data was wrong. And it was especially wrong in India. I felt we needed to have Indian statistics. Because if you want to make a difference and you want to make an effective change, you have to have data. So that's what we do.

We encourage people to document their stories and use these historical experiences to figure out the patterns and trends so that we can make better, hyper-local neighborhood decisions. It's about accountability to make change happen, but it's also about using evidence-based data to drive empathy.

After I started SafeCity, I remember I was in Sweden. The museums were open all night and we'd been out to see them. When we took the train back at midnight, I looked around and saw only women around me. Even in Bombay I had never experienced a train full of women at midnight. I actually felt comfortable and that's what I'm trying to achieve: a city where every woman and girl has a right to feel safe. A safe public space gives her the right to take opportunities which will allow her to access this potential quality of life.

ELSA MARIE D'SILVA is the founder of Safecity, an organization which uses crowd mapping to expose harassment and respond to sexual violence in India.

THE GAMBIA

JAHA DUKUREH

Ending female genital mutilation (FGM) is a political decision. Governments around the world should be held accountable for protecting girls. By raising more awareness, we educate people and communities to the danger of FGM and its harmful effects. Girls can thus be protected by letting them be the change we want to see in their communities.

The ways we achieve elimination of FGM might differ, but I would like to tell young women that by speaking out, not only do we save others, but we also heal ourselves in the process.

We are at a tipping point when it comes to FGM and how we address it because for the first time the conversation is led by women who are directly impacted by the issue—not someone speaking on their behalf, but them actually leading the conversation and the solutions.

I'm not an outsider. When it comes to the way people have received my story, you can't deny my story, you can't deny what I'm talking about because I'm speaking from lived experiences. I think it makes the movement more authentic and touches people more. Rather than hearing about someone's story, you're hearing from a real person. I think it has really helped.

When people spoke about FGM it was from the context of "those people from Africa," and "barbaric," so it wasn't from our perspective. As a result, not a lot of people cared. **I think once survivors started coming to the scene, it changed for the better. For the first time, our communities started listening to us. Our fathers started understanding our pain and our struggle. We broke the culture of silence.**

JAHA DUKUREH is founder and CEO of Safe Hands for Girls, an organization that works tirelessly to eradicate female genital mutilation.

ISRAEL

SHIMRIT PERKOL-FINKEL

WHEN WOMEN STEP OUT of their comfort zone and do something extreme with entrepreneurship, often there's a strong agenda driving them—a vision for social change.

When I started diving, I knew that I wanted to dive into marine biology. I started thinking about how we can support richer and more diverse ecosystems. I would see vast manmade structures along the coast and think, "Why don't we make these structures in a way that enhances marine life?" It became our mission to find out how to make concrete that could support ecological environments while being effective structurally.

There was real pushback initially. Engineers didn't want to think about fish or coral. They were focused on longevity and strength. Fortunately, we had the persistence to keep talking. We thought about how we could make people see marine life on manmade structures as a good thing.

I think that even if we stopped today, we have already managed to change the way the highly traditional coastal construction industry works. In many countries, ecological engineering is becoming mainstream. That alone was one of my main goals going into this business. From now on, everyone will think of the environment when planning construction.

If you have aspirations and knowledge, that is power to me. That's what I try to speak up about. I'll take any opportunity to talk to aspiring entrepreneurs. I think that it's important for people to see that what's possible. My hope is that my story inspires others.

DR. SHIMRIT PERKOL-FINKEL is a marine biologist, environmentalist and co-founder of ECOncrete.

LIBERIA

ELLEN JOHNSON SIRLEAF

IN CAMPAIGN MONTHS, I traveled to every corner of our country. I trudged through mud in high boots, where roads did not exist or had deteriorated past repair. I surveyed ruined hospitals and collapsed clinics. I held meetings by candlelight. I drank water from creeks and wells, all of which made me vulnerable to the diseases from which so many of our people die daily. I came face to face with the human devastation of war, but celebrated the resilience of a people to rise above this.

I ran for president because I am determined to see good governance in Liberia in my lifetime. But I also ran because I am the mother of four, and I wanted to see our children smile again.

My path to the presidency was never straight forward or guaranteed. Prison, death threats, and exile provided every reason to quit, to forget about the dream, yet I persisted, convinced that my country and people are so much better than our recent history indicates. Looking back on my life, I have come to appreciate its difficult moments. I believe I am a better leader, a better person with a richer appreciation for the present, because of my past.

All of the children that I meet, when I ask what they want most, say: "I want to learn, I want to go to school, I want an education." We must not betray their trust. Young adults, who have been called our lost generation, do not consider themselves lost. They, too, aspire to learn and to serve their families and their communities. We must not betray their trust.

ELLEN JOHNSON SIRLEAF is a Nobel Peace laureate and was the first female head of state in Africa, serving as president of Liberia.

SAMOA

ADI TAFUNA'I

THERE WERE SEVEN OF US, and what we thought we would do is form an organization and just support women going out and starting a business. But then we had two devastating cyclones. A lot more rural women were coming in and asking for help. And so, really, we just branched out into something we knew absolutely nothing about.

We started looking at these rural women who had no cash whatsoever. And we decided to look and see how they would be able to earn an income and realized that all they had was agriculture. For twenty-eight years now, we've been adding value to agricultural products by taking them to international markets.

> You're a true leader when you bring up a leader—when you're actually building up the people around you.

Years ago, we realized microfinance doesn't work in the Pacific the way it does in Asia. We are always lumped with Asia, but we are a total opposite. In our society, it is very difficult when the program is only for women. Men would get annoyed because women weren't doing the normal chores. So that resulted in our staff sitting with them and counseling them and now there's been a huge change with many families. We now work with families allowing family members to be supported when they take on additional roles.

One size doesn't fit all. We are twenty-two Pacific island countries and territories, each with a different culture. We've had success because we paid attention to the way people learn, to how culture and tradition works. That's the only way to make a real impact.

ADI TAFUNA'I is the co-founder and executive director of Women in Business Development, Inc., creating sustainable economic opportunities by innovating rural economic systems and stimulating trade in isolated communities in the Pacific region.

THE UNITED STATES

NANCY PELOSI

AS WE MARK ONE HUNDRED YEARS since American women won the right to vote, it gives me great pride to serve as Speaker of the House, with over one hundred women members!

When the Nineteenth Amendment was ratified, many headlines described this milestone as women being "given" the right to vote. That never happened—women fought for and won that right. Since the earliest days of America's history, women marched, mobilized, protested, picketed and were even jailed and beaten as they fought for their rights.

Generations after women won the right to vote, we would have to fight for another right: the right to take our seat at the decision-making table. When I came to Congress, there were only twenty-three women in the House; but we refused to sit on the sidelines. We knew our purpose and we knew our power—and we used it to make progress, demanding not only a seat at the table, but a seat at the head of the table.

Today, our nation is strengthened and enriched by the vision and voices of millions of women who are leading in every arena, from the statehouse to the Capitol, from the boardroom to the courtroom to the newsroom, and everywhere in between.

As Americans observe the one hundredth anniversary of the Nineteenth Amendment, we must channel the pioneering spirit of America's suffragists and rededicate ourselves to the important work left to be done to achieve true, full equality and to bring our nation closer to its founding promise: that all are created equal.

For those who aspire to lead, I say: Recognize the unique contribution that you can make, remembering there is nothing is more wholesome to our society, our economy, our security or our democracy, than the increased leadership and participation of women.

As we say: When women succeed, America succeeds!

NANCY PELOSI has been a dedicated public servant since 1987 and is the first woman Speaker of the U.S. House of Representatives.

DEMOCRATIC REPUBLIC OF CONGO

CHOUCHOU NAMEGABE NABINTU

WE QUICKLY REALIZED that our microphone was powerful. We used to broadcast testimonies of survivors; and it was really shocking to the community, when they listened to the testimonies of rape and sexual violence, and all of the atrocities. Before, it was like a kind of denial from the community. They suggested rape and sexual violence were the problems of women, but we said no, no, no. After that, we started a program of training young girls to become journalists. That's how I used my microphone to produce power.

When I was a young girl, we were taught that women should not speak in public. But when I started working at a radio station, I learned about women's rights and untapped talent—that everything's in me. And I took that opportunity to talk to women about the right to take a stand. **As a journalist, my microphone is my power—it is my survival.**

We had to put survivors in a situation to trust us, so they would give their testimony. We had to discuss it with them like it was our problem, too. And from that time, they started giving testimony to the community.

I had to teach women's rights to my family. I had to teach my brother. And really, now, I can testify that he has been the best ever brother. Because when we were growing up, he couldn't accept that he could help me with cleaning the house or the dishes. But I taught him that. That was the first place I had to change, in my family.

CHOUCHOU NAMEGABE NABINTU is the founder and director of AFEM, and a radio journalist who trains young women in the Democratic Republic of Congo to use the airwaves for activism against gender-based violence.

HAITI

DANIELLE SAINT-LÔT

IN ORDER TO CHANGE SOCIETY, you need to change behavior. You need to change attitudes. And the only way to do it, is to equip women to better raise boys and girls.

When you invest in women, you empower them. You transform their way of thinking and even change their mindset to be a real influence in their family, their community.

When I began seeing women that I had mentored in power, I realized that **I don't need to be in power; I just need to empower—to be like a queen-maker, instead of being a queen myself.** We need to crown more queens.

With a critical mass of women leaders globally, it will be easier for us women in undeveloped countries to sit down with them. We will have a seat at the table and be part of the conversation. They will be ready to listen to us and be our voices.

I was raised by powerful women, my mother and grandmother. I was also educated at a girls' school run by three female role models. And so, I realize that my leadership capacity comes from the women that raised me, the women who were my first mentors; and that's why it's quite easy for me to believe in the power and impact of women.

I think leadership is the capacity to use whatever you have received, whatever you have, to bring change. And you must do it collectively. You must have a collective mind. That's the only way you can succeed.

DANIELLE SAINT-LÔT is a lifelong activist and public servant, and founder of Femmes en Démocratie and the Danielle Saint-Lôt Haiti Women's Foundation.

THE UNITED STATES

GERALDINE LAYBOURNE

THE TRUTH IS, women haven't always been listened to and given credit for their ideas. They think differently so they sometimes rub people in power the wrong way. I have always felt comfortable with women's voices and I've always wanted to hear from them. That was the essence of why we started Oxygen Media.

My assistant had told people that if they wanted a meeting, they were going to have to walk me around because I certainly didn't need another meeting or a meal. Mondays and Fridays, if you wanted my advice you had to walk with me at 7 a.m. in Central Park. So, we had the idea of creating a mentor's walk. For me, it was about showing that women help each other and being visible about it, hoping that people would make this a daily practice.

In 1990, I got my first award. They asked me to speak about how I had succeeded. I began simply: I succeeded is because I was a woman. You could hear a pin drop. People were gasping. It was very fun. I talked about how my son at two taught me customer service and how to manage my boss. Years after, everyone who got that award talked about how they succeeded because they were women.

I feel like the women of my generation broke glass ceilings, we were so happy to have jobs that we weren't thinking about leading differently. If you look at a journal study about how to lead in the twenty-first century, they are all female traits. Slowly but surely, men are leading more like women. God bless them.

GERALDINE LAYBOURNE is the co-founder of Oxygen Media.
She has revolutionized cable television for children and young adults,
and uses her platform to elevate the voices of women and young people.

INDIA

NEYSARA

B EING TRANSGENDER IN INDIA, it's really difficult to even come out in the open and say, "I'm a transgender woman." But nothing is going to change until transgender voices rise against injustice.

People like me lose our rights, we don't have legal protections and rights of human beings in our country because we are not counted as citizens. Even to get back my own human status after I transitioned, all we could do was forge documents, just to get some identity. That's how most trans people in India got their identities back then.

Power is the ability to fight in the face of injustice—fighting even after being struck down by failure. It's a journey. You have to derive power to just stay on the journey and get up every day and fight back and say, "This is injustice and it's not something that I'm willing to accept." That's powerful to me.

Through the journey of being raised to be a man in a very patriarchal society, I was shown all the privileges of masculinity that are conferred to you. And then, when you transition, you become subhuman. That's when I went back into the closet. I was terrified by the reaction of society to me just wanting to be me.

A lot of times, when I speak to transgender youth, I am the first transgender person they have ever spoken to in reality, and who has spoken to them as a normal person—knowing they are a normal person. It makes them feel so empowered and it's a feeling beyond explanation for me, giving them the courage to just stand up for who they are.

NEYSARA is the founder of TransgenderIndia.com, an initiative built to empower transgender people across India.

THE UNITED STATES

JAMIRA BURLEY

VIOLENCE IS OFTEN A MUCH DEEPER, systematic problem. Over the last fifteen years, I've been on this journey of really trying to understand what are those systematic problems, and who are the people at the center of tragedy, who also could be at the center of change.

I was lucky. If I think about the trajectory of my life, every opportunity, every mentor, every person I've come in contact with, it has been a series of fortunate events—work, too—that can only be attributed to luck. However, I want to create a world where young people don't have to be lucky in order to get access to resources and opportunities, to voice their concerns or ideas, or for others to see them as being worthy of being listened to.

Every woman who has helped me along this path has defined how I show up. I think women not only see issues differently from men, but more importantly, we're willing to share space differently.

My experience is just one. It might be indicative of other youth experiences around the country, but there are nuances to every single issue that impacts young people. The more voices we have at the table, the more we can really think about how solutions can benefit those who are at the margin.

I think that people are asking more questions now, looking more internally to themselves and their communities, and thinking about intersectionality beyond their own individual experience; and that leads to a much deeper conversation around having empathy, around justice, and asking what could the future actually have in store for us.

JAMIRA BURLEY is the founder of GenYNOT, and a social justice activist.

HONDURAS

MAYKI GRAFF & SUAM FONSECA

SINCE WE WERE GIRLS, we were raised with stereotypes of how women should be, what we should and should not do. Today, we break those schemes, and we want women around us to empower themselves and achieve the same personal freedom, through art.

Being women graffiti artists is like a blow to the system in a society permeated by machismo. It's been revolutionary. In Honduras, there is graffiti art; but it's mostly done by men. So, it's considered taboo for a woman to suddenly swoop in and start painting in the streets. With that said, it's cost us a lot to get to where we are. Day by day, we are pushing ahead, and, because of that, we are seeing the fruits of our labor.

We created Dolls Clan because there's a lot of machismo in Honduran culture. But through art, lives can be changed. Important messages can be transmitted and used to protest. We provide a message of power, a message of strength. We show that women can develop in the space they want.

We believe that everything begins when we see other women as non-opposing allies. As alliances are being built, and more women and girls become leaders, the difference will be noticeable from home, work, schools and communities—the voice of women will be taken into account, and more women will stop being afraid to do the things that they want to do.

Women, youth, girls and boys have seen through graffiti what we can do—girls and women are empowered, and the youth and boys learn to live in a shared society and not a patriarchal one, allowing us our own spaces.

MAYKI GRAFF & SUAM FONSECA are the founders of Dolls Clan, Honduras's first group of feminist graffiti artists, creating art and music that defy taboos, protest femicide and defend women's reproductive rights.

THE UNITED STATES

KARLIE KLOSS

I WAS SO IN AWE of what was happening in tech but frustrated that I didn't understand it; so I learned to code to find out more about this powerful language. Being able to understand the building blocks of technology? It can turn the lights on. It turned the lights on for me.

Education is such an important and powerful way of creating the kind of future you want for yourself. It can open up so many doors for girls and young women. I started Kode With Klossy because **I really believe that we are capable of anything and everything we set our minds to. And now more than ever we have opportunities for girls to earn anything they want to.**

KARLIE KLOSS is an American entrepreneur and supermodel whose nonprofit, Kode with Klossy, offers free coding classes to young women, empowering them to pursue careers in computer science.

NIGERIA

HAFSAT ABIOLA-COSTELLO

WHAT WE SEE IN THE WORLD now is not how it would be if women were fully present; what we see is a very competitive world, a world that doesn't care for the vulnerable. If more women were in charge of their own destinies, coming forward with their own ideas and imposing—insisting—on having their own space for their ideas in the way the world is being shaped, we would have collaboration, we would have partnership, and then the world would be in better balance.

Because I had seen the impact my mother had when she decided to seize her own destiny in pursuit of a larger vision for democracy in my country, I wanted to help create an organization that would empower women in Nigeria in that direction—to impose their understanding, their compassion, their own concepts on the future.

In a way, you have to turn down or set aside a lot of society's expectations and write your own expectations. You must have your own vision determining how you allocate your time.

One of my favorite pieces of advice, I got from a New York taxi driver. I speak softly and he couldn't hear me. He said, "You've got to speak up for yourself, girl!" You know, I've never forgotten what he said. For me personally, and for women in general, I think this is one of the most important lessons. We do not speak up for ourselves enough. And we have to learn to. It's fundamental.

HAFSAT ABIOLA-COSTELLO is founder of Kudirat Initiative for Democracy (KIND) and president of the Women in Africa Initiative.

THE UNITED STATES

LAURA BUSH

THE WELL-BEING OF WOMEN is essential to a good future for our world. Studies show that when you empower women, entire communities and countries thrive. When women are included in the economy, countries are more prosperous.

We know from research that when mothers are educated, their children are more likely to be educated and successful. And when women are healthy, their families are healthy. The inclusion of women in all aspects of society strengthens and improves the stability of their countries.

Investments in the success of women are investments that pay off. And through the Bush Institute's First Ladies Initiative, the Afghan Women's Project, the WE Lead Program, and our global health initiative—Go Further—President Bush and I are committed to investing in women for the rest of our lives.

Despite the dire headlines we read, there is reason for hope for women around the world. The accomplishments of courageous women around the world, remind us of that.

All we know we have is now. I ask you to think about the women who will make even more progress in the future—millions of women around the world, and maybe even my two precious granddaughters, Mila and Poppy Louise.

Consider the legacy that we'll leave for our children. The choices we make now will shape the world for the next generation.

LAURA BUSH is a former U.S. first lady, and has used her voice and platform to advocate for the rights and opportunities of women and girls in Afghanistan and around the world, and increasing access to education.

ARGENTINA

LAURA ALONSO

M ORE AND MORE, AS I BECOME OLDER, I realize that if I lose this position, I am not losing my life. I have always believed in the idea of autonomy; and now, I am always ready, if I have to go. There are some things I will never negotiate. So, if my values are not met, I will go.

It has not been easy. When you are in the public eye, criticism is tougher. It comes with a cost. Some days, I don't want to read the papers. I ask myself, "So, why do you go on? Why do you persist? Are you stubborn or do you know deep in your heart that you are doing the right thing?" It has been very difficult. But I think staying and persisting gave me a lot of power. From within government and from outside, people saw that I didn't quit, and they respect me for that.

It took me years to reach this point. But now, I feel that I am an authority. People are not indifferent to my voice. When you speak, you are influencing people, whether for right or wrong. Now, I feel that if I say something, it can either create a problem or a solution, but no one will be indifferent. And that gives you a different kind of power.

> Before, I used to think about positions and platforms; now, I feel like power is inside me. Now, after all my time in office, I feel that I can be myself.

LAURA ALONSO is a former congresswoman, secretary of public ethics, transparency and anti-corruption, and head of the Anti-Corruption Office of Argentina. She courageously calls out corruption and demands increased government accountability.

THE UNITED STATES

JESSICA HUBLEY

WE HAVE TO CONQUER BIAS, and we have to become bigger than it. We can do that if we just keep on putting the truth out in the world, until it's so loud that it's undeniable.

Our society has devalued survivors, and we turn that into an opportunity that no one else takes, because they can't see it. AnnieCannons teaches software programming and helps transform human trafficking survivors into software engineers that build software for us. And it's working. The question isn't whether they have the talent, though. These women are incredible. For me, it's been about putting a system in place to allow them to reach their full potential for themselves.

The reality is that the women that we are training are all exceptionally bright, but they were given no educational opportunity. They are incredibly talented when we meet them, but continue to be marginalized because they are women, because they are survivors. That's an incredible pool of talent that most are unable to see through the lens of their own bias.

There's something powerful about doing more with much less. Over time, I've learned that underestimation because of how you look and what your gender is, can be an advantage. It, however, can also be a burden. To be taken seriously, you have to spend the first fifteen minutes of any formal conversation proving who you are and what you've done. That means an opportunity to impress and surprise. If we help survivors impress and surprise enough, their value becomes consistently harder to deny.

JESSICA HUBLEY is lawyer and activist transforming survivors of human-trafficking and gender-based violence into software engineers and entrepreneurs through the organization she co-founded, AnnieCannons, Inc.

INDIA

SOHINI CHAKRABORTY

I THINK THAT WITH TRAUMA, it is important to focus on the body, because body and mind are inextricably connected. Both physical and emotional effects of trauma are stored in the body; so, body-based methodology is required for recovery, but it is rarely found in psychosocial rehabilitation. When you experience Dance Movement Therapy (DMT), you are sensing your body and acknowledging the effects of trauma, which is necessary for healing. It's a powerful tool for recovery.

I use dance movement therapy as a psychosocial rehabilitation tool for survivors of trafficking and violence. I believe that everybody in society should live with dignity and respect, and this basic sense of empowerment can be achieved through dance movement therapy.

It is important for any individual experiencing trauma to move ahead with life. Through our process, survivors find liberation in the body, which helps them to access freedom holistically for life and in society.

DMT gears up the rehabilitation process because it gives you physical confidence, eye contact, focus, emotional regulation skills, and ability to communicate with larger society, including when a trafficking survivor testifies in court.

I'm a very motivated person. And that helps me with resistance. I think about how I can use my inner power. **I think that when a person digs into that inner power, a lot of things can happen. It brings strength, motivation and freedom.**

DR. SOHINI CHAKRABORTY is the founder of Kolkata Sanved, pioneering dance movement therapy as psycho-social rehabilitation for survivors of violence.

THE UNITED STATES

GEENA DAVIS

WE DON'T HAVE TO WAIT FOR SOCIETY to turn things around. We can create the future now, through what people can see on screen. And then life will imitate art.

There is one category of gross gender equality that can be fixed overnight: on the screen. The next project that someone makes, the next movie, the next TV show—it can be gender-balanced. We can make this change happen very fast. In the time that it takes to make a new TV show, we can present a whole new vision of the future.

Fifteen years ago, when I first sat down with my daughter to watch preschool entertainment, I was thunderstruck by how few female characters there seemed to be. It was a life-changing revelation to realize that we are in effect training children to have an unconscious gender bias from the beginning, by communicating to them that there are more boys in the world, who do most of the important things.

I didn't intend to take on a mission, originally. Instead, whenever I had a meeting with a creative in the industry, I'd casually mention the dearth of female characters in kids' movies and TV, and every single person said, "That's not true anymore." They would often name a movie with one female characters as proof that gender inequality had been fixed!

That showed me that even the most well-intentioned people have unconscious bias. If there was ever a sole smart or capable lead female character, they believed they'd already covered women and girls—that one female character is enough, as long as she is significant. That the populations they were creating didn't need to be half female. That's why I wanted the data. With the data, they finally see the problem. And they're fixing it.

GEENA DAVIS is an American actress, activist and founder of The Geena Davis Institute on Gender in Media.

THE UNITED KINGDOM

BALJEET SANDHU

I WAS A DEFIANT AND CURIOUS CHILD—defiant of oppressive systems that controlled my life and my family's lives, systems that suffocated the love and joy in my community; but curious about how I could activate my lived experiences of social and economic injustices to create positive change for others.

But even as a child of migrants, I had no idea that there were extremely vulnerable, unaccompanied children from around the world living in my community. Children who were arriving in the U.K. alone from war-torn countries, or those rescued from the evil clutches of human traffickers. Children who were treated as migrants first, and children second, in policymaking and service design. As a community organizer and youth worker at heart, this didn't make sense to me. That's where the fire in my belly started.

> I soon began challenging the legal sector. However, my plea for a more child-centered approach to legal service design didn't go down very well. Ultimately, I was disrupting a very traditional, hierarchical and patriarchal system.

I feel very blessed. A lot of my peers are having an existential crisis and trying to figure out their place in the world; but my vision for change has always been clear and driven by my own lived experiences—to protect the rights of marginalized children so that they can thrive as well as survive. I also feel honored—honored to work alongside inspiring young leaders with lived experience who continue to guide our systems change practices.

BALJEET SANDHU is a child rights advocate and lawyer whose organization defends the rights of young people who have been displaced by war or exploited by human trafficking.

RUSSIA

MARINA PISKLAKOVA-PARKER

IT WAS COMPLETELY INVISIBLE IN SOCIETY. There was not even a word for domestic violence. It is basically a taboo to talk about it. We still don't have a law against it.

I was working on draft legislation and there was a backlash, and my organization was listed as a foreign agent. And I had to announce this news at a conference with our national network and neighboring countries—because cooperation with us would become risky for others; and you know, I can tell you that of one hundred organizations, not one stopped working with us. That level of support actually gave us the strength to go through this very difficult time.

My motivation was born from compassion. When I met mothers of my son's classmates, and they were suffering from domestic violence. I said, 'Why don't you just leave?' And she asked me, "Where would I go?" Then, I called the police and called medical doctors and social services, and everywhere they said, "It's a private matter, we do not intervene." So, there was my starting point.

A lot of women that I know in our movement, start with compassion. Basically, it's about healing the suffering of another woman. When I started the helpline for battered women, it was the minimum that I could do to support them. My initial motivation was really just to give a chance to women, to just listen to them and help them as another human being.

We shouldn't fool ourselves, there are different types of women in power, when we talk about power. It's not the fact that women, by definition, will use power differently from men. But I think women leaders that want to lead humanitarian change, equality change, these women will always be looking out for others.

MARINA PISKLAKOVA-PARKER is the founder of ANNA (Association No to Violence) and a fearless human rights leader who defends women's rights and established the first hotline for survivors of domestic violence.

TANZANIA

VICTORIA KISYOMBE

ONCE YOU EMPOWER women economically, you increase their ability to be equal. I believe that when women are economically strong, their voices become stronger. They gain independence, and people begin to take them seriously. I have seen it in my own life.

When I was working as a veterinarian, it was difficult for me to make ends meet. I had to do something more to generate income to support my children. We had a cow, and I started selling milk. I reasoned that if I can generate daily income from this cow, then it's a productive asset. Then I started thinking of other women with the same problem.

Because of cultural challenges, most women do not own or inherit property. That leaves women without collateral, which financial institutions require. To circumvent this problem, I decided to use micro-leasing—where the leased asset stands as collateral. Women lease assets like tractors and milling machines to generate income, and at the end of the contract, they own the asset. To date we have financed 31,000 loans, revolved $19 million in credit, created 155,000 jobs and impacted 300,000 people.

Things are changing. For the women we are financing, once they generate income, they are able to buy land. The laws weren't stopping them, it was their purchasing power. But now, more women are owning land as well as their own houses.

Empathy is number one to me. Probably because I have faced similar times, I understand the women we support. That helps me a lot. It gives me energy and satisfaction when I see that I supported a woman from almost nothing, and now she's growing her business. That is very fulfilling.

VICTORIA KISYOMBE is a veterinarian-turned-social entrepreneur and founder of the micro-leasing company Selfina.

PHILIPPINES

LEAH LIZARONDO

'M FIGHTING FOR THIS RETURN to belief in ourselves—that we can get things done and we can take part in something that is good and of service.

We're creating a global movement to end waste, end hunger and reverse climate change.

I have a love for food; and I'd never been able to marry that with my career trajectory, until I read a National Resources Defense Council report that said we are wasting almost half of our food supply. That was a big wake-up call. I wondered, "Why is no one doing anything about this?"

The decision to become an NGO was very deliberate. I was hyper-aware of the fact that only 2 percent of venture capital goes to female-founded companies, less than half of that to minority-founded companies, and even less for social good organizations. Looking at that, I was trying to hedge my risk and thought, "I don't want this to die before we can prove it."

I knew that technology was essential to scale. Our technology matches excess food from grocery stores and restaurants to charities that need it; and we mobilize thousands of volunteer drivers to deliver that food. We call them food rescue heroes. They respond to push notifications like a bat signal.

The hardest part about our model, when we talk to investors, is that we are powered by volunteers. Surprisingly, betting on people is a risk. They say, "How reliable are volunteers?" And I never had a number or proof that would satisfy investors, before. But now, I do. We have a 99 percent service level—our food rescue heroes, driven by their desire to do good, only miss 1 percent of our rescues. People literally deliver. And food is only the beginning.

LEAH LIZARONDO is a pioneering social entrepreneur, and founder and CEO of 412 Food Rescue.

THE UNITED STATES

DEBORAH RUTTER

WE NEED TO THROW THE DOORS WIDE OPEN. That's where all of the arts are headed—to this more participatory, immersive experience. If we flip the traditional live performance experience, and adopt a patron-centered approach, suddenly, the possibilities are boundless. Age-old barriers start to break down, and eventually, disappear. More people feel welcomed and invited to the table.

Our cultural institutions have a tendency not to want to take risks, because there's not a lot of room for error when you are beholden to box-office revenue. **We must test new ground and challenge the depths of our creativity. We cannot rest on our laurels or play it safe and say, "It used to work this way, so we will continue to do it that way." Nothing in life is like that, so we as an institution have to take as many risks and be prepared for failure.**

I believe that if you are coming together as a society, as a culture, you have to understand how all our art forms can live and evolve today. Whether it is music composed one hundred years ago, last week, or improvised in the moment, it is being performed with the head and soul—the technical capacity and imagination—of people who are alive today. The answers to our present and future are there if we unleash the creativity of our artists and listen to and challenge our audiences.

This mindset has been key to our success with the REACH, the Kennedy Center's new modern annex that opened last year. It's now a gathering space brimming with experimentation and inclusive of a wider range of art forms, and even disparate art forms accidentally colliding to make something new and exciting. Audiences crave the unpredictability, bravery and community of these unique artistic moments. And most importantly, we are building trust with them, and developing lifelong habits of patronizing the arts on a formal and informal basis—and everything in between. The value proposition of the Center's brand has shifted from "Watch Us" to "Join Us."

We are nonpartisan—not bipartisan—but a nonpartisan institution. The divisiveness we encounter in society today is actually something we're trying to respond to by creating spaces like the REACH—welcoming to all people, all ages, all backgrounds, all art forms. Whether you buy a ticket to a show or come for a free program, this is your cultural center. We're here for all people.

DEBORAH RUTTER is president of the John F. Kennedy Center for the Performing Arts, and is the first woman to lead the renowned national arts institution.

TUNISIA

AMIRA YAHYAOUI

BEING A WOMAN used to be seen as something so negative; but now, people are starting to see our value and are trying to learn from us.

For our generation, our decisions aren't always about what's best for ourselves, but what's best for others. In my case, when I became a human rights activist, it was not about what I was going to gain out of the venture, but more about how I was going to go about helping others.

It was a huge privilege to defend our democracy and prove to the world that human rights are universal.

My hope for the world is that we become more self-aware, which is already becoming the case; but there is still so much work that needs to be done.

I am constantly trying to convince the women around me that between choosing to work for someone to create their thoughts, or to be a leader, a CEO, or to run for office, they should choose to be leaders.

I think that women used to lead like men because that was the only way to go about leadership at the time. But today, for the first time ever, we are able to see women leading like women; like the New Zealand prime minister, who is unapologetic about her gender, as well as who she is and how she acts.

AMIRA YAHYAOUI is a Tunisian human rights leader-turned-tech social entrepreneur who uses her voice and talents to create radical transparency through her organization, Mos.com.

THE UNITED STATES

AMANDA NGUYEN

THERE ARE PLENTY OF TIMES when, as a young woman of color, I come into a space where I am not accepted. And it's been painful. Those experiences keep reminding me that I don't belong. So I reached out to other women of color, organizers and activists, to ask for their advice. Their advice was to just keep going. It was difficult to hear, at first, but they said: "You know, this is the cost of what it means to be first. You're the first person to look the way that you do in this space, and the only way for it to improve is for you to keep existing in these spaces."

I had no idea how broken the criminal justice system is for survivors until I became a rape survivor myself. **At that moment, I realized I had a choice: I could accept the injustice, or rewrite the law. I chose to rewrite it.**

Through Rise, we've been working to make the world recognize that survivors and survivor rights are a global priority. I think that change requires both legal and cultural change; and they're threads that intertwine.

I think that one of the most important parts of the Declaration of Independence is the "pursuit of Happiness" clause. It says that, as people, we get to define—every generation gets to define—what that means. That essentially gives us an ability to keep the American experiment as an experiment, that we can iterate for an ever more perfect union.

AMANDA NGUYEN is a survivor, an activist and founder of Rise.

CUBA

YOANI SÁNCHEZ

I DON'T THINK THAT THEY'RE AFRAID OF ME; I am one person. They can easily eliminate me. What they're afraid of, is this phenomenon: More and more, people are projecting their voices in this alternative world. They're experiencing freedom through technology. And it's tremendously contagious. This new phenomenon can't be fought with old weapons.

I still remember the odor of the gas masks we wore, running to the shelter in military practice during school. So many Cubans came of age with fear, always on edge. In all that time, preparing for a battle that never came, we overlooked the main confrontation—the one within ourselves. Are we ready to speak the truth or do we still believe dissent is treason?

I began posting chronicles of reality. From my life, from strangers. These small pieces started adding up. They revealed Cuba. And people took notice.

After you cross certain lines, there's no way back. *Generación* Y allowed me to say, in this space, what's forbidden in the streets of Havana: the truth.

Censorship is one form of control. Connectivity is another. *Generación* Y has been blocked since 2008. So, we find other ways. Anonymous proxies, USB drives, photocopies. I would sneak into hotels just to use the internet.

Unfortunately, for many, Cuba has become a theme park to photograph beautiful ruins, old cars and lovely beaches. Many would like to go to our country "before it changes" instead of setting out for a visit that helps us change our reality.

YOANI SÁNCHEZ is a blogger, journalist and voice for change, pioneering a movement to establish a free press in Cuba. She is the founder of 14ymedio, Cuba's first and only independent digital news outlet.

THE UNITED STATES

LAURA LISWOOD

IF YOU EXPERIENCE LIFE as a member of the non-dominant group, you develop different skillsets. You develop different survival techniques, different ways of interacting with people.

I think about the elephant and the mouse. If you're the elephant in the room, what do you need to know about the mouse? Not much. But if you're the mouse, what do you need to know about the elephant? Virtually everything. That is sort of the definition of what we consider empathy—this understanding of the position of another, and being aware of the position, concerns and feelings of another. For women, being the outsider, being less powerful, you develop techniques like empathy.

I think that we've come to this realization that the skillsets that women bring by their very experiences in life turn out to be extremely important for great leaders—when it comes to getting people to be motivated, to have good relationships, to want to be part of an enterprise. Collaboration and the notion of consensus turn out to be very important.

If you are the only O in a room of X's, generally speaking, you are just going to try and change yourself into an X. But when you have a critical mass of O's, then the true O-ness, if you will, a true women's approach, can come out and be fortified, and be seen as normalized.

LAURA LISWOOD is the co-founder and secretary general of the Council of Women World Leaders.

INDIA

KIRAN BIR SETHI

THIS WAS ABSOLUTELY NOT PART OF MY PLAN. I graduated as a designer; and I attribute so much of what I have done since, to this design mindset.

When I went to meet my son's teacher, I asked, "How is my son doing? What are his passions?" She looked at me and said, "What is his number?" And just in that instant, what instantly took me aback was that this boy had merely become a statistic within a massive education system. As a mother, of course I was upset. As a designer, my first response was, "What is the better way? What if there was a way that my son could have an education that would give him voice and choice?"

I soon gathered the confidence to go out and create my own school, which was not this grand plan to change education, but more of a simple story, from a mother, saying, "There has to be a better way to look at education."

It's been extremely gratifying to see that globally, there is this need that has been perceived that children must be more than their marks, that there's a higher purpose of education.

The space that I am in at the moment, I think that I must have stamina and passion to work and be shameless with it—because **passion is really the key that will sustain you.** The world will keep asking you "Do you really, really want this?" It will keep testing you, because it's so easy to give up.

KIRAN BIR SETHI is the founder and director of The Riverside School. She is revolutionizing the school system in India by encouraging children to solve real-life challenges and be citizens of the world.

THE UNITED STATES

MEGHAN MARKLE

AS WE CELEBRATE the centennial of the Nineteenth Amendment, we honor all of the women who envisioned a world where their voices were heard as clearly as their fathers', brothers', husbands'—a world in which their daughters mattered as much as their sons.

We see what they saw, and we honor them by continuing their work. Because we have the privilege of standing on their shoulders, we can also see what they could not—that everyone has a seat at the table of equality. As a woman and a woman of color, I am proud to take my seat at the table, knowing that there is always room for others, and that by creating a better future for our daughters, we are also creating a better future for my son, Archie—and for all of us.

When women succeed, we all succeed, and when we learn to believe in one another's worth, we will all come to know our own infinite worth.

MEGHAN, DUCHESS OF SUSSEX uses her platform to advocate for women's rights globally.

RWANDA

CHRISTELLE KWIZERA

IT'S BEEN A WAKE-UP CALL to work faster. In a way, we were fighting a water crisis already. But now with the coronavirus pandemic we feel an urgency to take action. So, our goal before was to connect at least two or three households with in-house access to water per day; now we can even try eight. If we can connect more people at home, we're going to see better rural areas.

The data shows that every day, African women are wasting over 200 million hours collecting water. That is nearly 40 billion hours a year. This is because most families don't have access to piped water inside their homes.

Public water points are not the end goal. We must provide water inside people's homes. So, I really hope that other water providers, especially NGOs sponsoring projects in Africa and elsewhere in the world, ask themselves, "Why do they still provide public points? What can they do to make sure that water is available in people's homes?"

There is a longer policy outcome, I believe, for the water sector in general, especially for the water sector in rural Africa, which for many, many years has been all about creating public water points. I hope we can question our numbers, look at the real access to water inside homes, because with ongoing climate change and pandemics, things happen that force people to stay inside.

We feel very positive about the solutions we're bringing; so, we feel more motivation to keep bringing them. We've had many people reach out wanting to be part of the effort. It's been very comforting to get messages from strangers. Other people are telling us, "We're with you, stay strong."

CHRISTELLE KWIZERA is the founder of Water Access Rwanda, an award-winning innovative social enterprise offering tailor-made solutions for the collection, distribution and purification of water.

THE UNITED STATES

CHESSY PROUT

THE DAY I BECAME A SURVIVOR, I had an immediate circle of friends and family who supported me. It was only after the school got involved that I met resistance.

Much later, I found out that the prosecutor didn't want to take my case. He thought that it was a "he said, she said" situation that he couldn't win. Fortunately, a female prosecutor overheard this and said she wanted to take on my case. She believed firmly that nothing would change unless they took on the harder cases. And I'm very thankful for that.

When I realized that so many people identified with my story, I felt less alone; so I wanted to make other people feel less alone, too. I wanted to create a community that would validate people's feelings, to make them feel like they are not alone in the process of claiming survivorship.

Starting these conversations around sexual assault and consent is tough; but it's something that has to happen for people to be and feel safe and respected. The schools that claim to have zero reports of sexual assault or harassment are the places to be wary of. In the past couple of years, so many schools' reporting rates have spiked. I think it's a result of students feeling comfortable to come forward, which is a good thing.

I am constantly trying to find my own place in the world, and I think there's a lot of power in that. Right now, I am doing a lot of listening. I feel like that I have so much more to learn, to find out where I need to be to promote social change.

CHESSY PROUT is a college student, survivor, author and activist.

GUATEMALA

CLAUDIA PAZ Y PAZ

> **START FROM the conviction that the truth is a transformative force.** Many times, perpetrators or groups who sympathize with them try to hide what happened. The truth dignifies the victims. It is a form of social recognition of what they have suffered, and thus, it has a restorative function.

When I applied to the post of attorney general, I was breaking with all those voices that were telling me that it was not my place, that I would not be able to do the work, that I was not prepared for such a position of power.

The struggle for women's equality is a long process that does not have a point of arrival, because there are many starting points. It is not the same to fight for equality as an adult, mestizo, middle-class woman as it is for an indigenous girl with limited resources. It is not the same to seek equality in Guatemala or Haiti as it is in Sweden or France.

I believe that, as women, because of the discrimination and exclusion that we have suffered, we build our legitimacy from different places compared to men—in a more horizontal way, listening, generating consensus. These forms of leadership are very important to implement in teams, and help facilitate deeper and more sustainable processes.

It is important to make people visible—who they are, what they have lived, why this has happened to them. This way, we can identify and feel what unites us. We understand that the people who suffer human rights violations are not "the other," and that it can be any of us.

CLAUDIA PAZ Y PAZ served as Guatemala's first female attorney general and has made it her mission to restore integrity to her country's justice system.

THE UNITED STATES

MADELEINE ALBRIGHT

Soon after being sworn in as secretary of state, I remember being asked what it was like to be the first woman to hold that job. I said, "Well I've been a woman for years, but I've only been secretary of state for a few minutes."

At the State Department, I decided that women's issues had to be central to American foreign policy, not only because I am a feminist, but also because I believe that societies are better off when women are politically and economically empowered. That's because women will raise issues that others overlook, pass bills that others oppose, put money into projects others ignore and seek an end to abuses others accept.

In the last two decades, the agenda for women has widened. Our place on the international stage is no longer primarily as an object of humanitarian concern. Our rightful role is as a full partner in establishing every aspect of public policy, from the quest for peace and prosperity, to ensuring that modern technology serves important social needs, to advocating for the environmental health of our planet and conquering disease.

The time has long past when one might fairly divide the public interest into so-called women's issues and those of more general significance. As presidents, prime ministers and foreign ministers, legislators and judges, mayors and military commanders, women have shown the ability to lead on all fronts; women deserve a full and equal voice.

Years ago, Margaret Mead urged us never to "doubt that a small group of thoughtful, committed citizens can change the world… Indeed," she said, "it's the only thing that ever has." The women and men who fight for women's rights no longer comprise a group that is small. We are thoughtful, we are committed, and have no doubt—we will persist until we prevail.

MADELEINE ALBRIGHT was the first woman to serve as U.S. secretary of state. Her staunch positions and strategic approaches showcased the way in which women lead differently.

INDIA

AKANKSHA HAZARI

M Y TRAJECTORY would be considered an unexpected, unlikely outlier. I aspire to create a world in which it is not, a more fair and equal world.

Our beginnings were humble, unstable and incredibly challenging. **"The value of your life is defined by the positive difference you make in the lives of others."** My mother reminded me of this every day as she worked two jobs, went to school and raised two children. This engendered in me a deep, intrinsic drive. I became determined to use our circumstances not as an excuse to fail, but a reason to succeed.

We focus on using technology to empower local retailers. There are more than 60 million family-owned, local businesses in India, that drive the vast majority of retail in the country. Most importantly, though, they account for more than 40 percent of local employment. Now, however, with competition ranging from e-commerce to big box stores, and a new digitally-driven consumer to serve, local retailers are presented with a new set of challenges that could put many of them out of business. We have built a full suite digitization platform to empower local retailers to not just survive, but thrive. My favorite part of my job is meeting our customers and learning from them.

No matter where our journey begins, we should have equal access and opportunities to achieve our aspirations. This is the world I hope to help realize.

AKANKSHA HAZARI is founder and CEO of m.Paani, an organization using technology to transform how local retailers in India do business.

THE UNITED STATES

FAITH FLOREZ

MY GREAT GRANDMOTHER came here from Mexico to plant roots in this community of farmworkers. She encouraged everyone to vote and speak up and become advocates. I never met her because she died before I was born, but I always felt connected to her. My grandparents would always say that I reminded them of her.

I definitely have a lot of hope for the future with my generation and with all the social movements and activism in recent years. **I think that it's very important that we listen as leaders and make sure that the spaces we create are intersectional and inclusive. That's the only way we can ensure that every voice is heard.**

I started working on the app in my sophomore year of high school. The initial idea was oriented around the threat of climate change in my community. Temperatures in the summer were beginning to become unbearable. Workers were in one hundred-degree heat for long hours. We have regulations now that protect workers, but that isn't enough. I wanted to create a platform that educates workers on their rights and to be aware of how dangerous it is to work on the fields, especially with climate change.

I think our ability to make an impact in the digital era is so much greater, especially for women. Behind every successful woman is another successful woman. No matter what, women have the ability to back each other up. I know that society tries to pit us against each other, but I think it's important to lend a helping hand to young girls and give them support. With the digitalization of everything, I think that process is becoming easier.

FAITH FLOREZ is the founder of the Latina Legacy Foundation, which defends worker's rights and informs farm workers of their rights—especially in extreme weather conditions.

LEBANON & SYRIA

ROUBA MHAISSEN

GREW UP BETWEEN TWO COUNTRIES, spending weekdays in Lebanon and weekends in Syria. I was visiting my family in Lebanon, watching TV, when the first forty families crossed the border. At the time, they weren't even called refugee families—they were simply families, and I couldn't believe what I saw.

A lot of people come from abroad, whether as activists, journalists, donors or international organizations, and they come into our world without knowledge about our society. Oftentimes this neocolonial mentality doesn't listen to the needs of the community.

Even projects that come with a good intention of achieving gender equality end up creating hostility with men. The men either ban their women from these training programs, or they feel sidelined and like they are having a masculinity crisis. Not taking men into consideration when designing these programs, they're only concerned with outputs of a specific program and achieving strong, fast changes, rather than working bottom-up to change the mentality and the culture.

We work with the community, for the community. We believe in achieving gender equality through empowering the community to use their systems of belief and their values to achieve incremental change in the mentalities of youth and men.

To be a woman activist and vocal about these issues is not an easy thing anywhere in the world. **I think all change is really difficult and we have to be open and optimistic that these little, small, incremental changes that we're making will eventually mount up to something bigger.**

ROUBA MHAISSEN is an activist who promotes locally led solutions in Syrian refugee and host communities across Europe and the Middle East, through her organization, Sawa for Development and Aid.

SOMALIA

HAWA ABDI & DEQO ADEN MOHAMED

WHEN THEY CAME, we were informing them, "If you use the clan division, or you say 'I am that clan,' you cannot stay here. You will be Somali. And you will see, we will welcome you."

We have given our community our soul and our heart. All our lives, we have been helping the people who needed our help. To have money and get elected in politics is not happiness. The best happiness is when we help people that are suffering. If we can help them pass suffering, when they are sick; to eat, when they are hungry; to give them clean water when they are thirsty.

My mother remembers Somalia as the most beautiful place and Mogadishu as the prettiest city in the world. She cannot forget this. She wants to see Somalia return to what it was before. We are waiting, and we hope that it will become what it once was.

We have been educating our young in all honesty and hard work. Our young people are not torn apart by tribalism, they do not fight by tribe. They are very proud of their Hawa Abdi roots. When you ask them where they come from, they proudly say, "I am from the people of Hawa Abdi." Most of them ran from their clan and came to us. We offered to give them water, shelter, healthcare and education for free, only if they stay away from clan politics. We are hopeful that in the future, some of them will become leaders in Somalia.

My mom created a beautiful camp and village. People get used to this peace and comfort. Now, I want them to also take part in society, to be part of society, and not only this village.

DR. HAWA ABDI & DR. DEQO ADEN MOHAMED are mother-and-daughter physicians who provided refuge, healthcare and community for as many as one hundred thousand internally displaced Somalis. Dr. Hawa Abdi is founder and chairperson of the Dr. Hawa Abdi Foundation, while daughter Deqo is CEO.

THE UNITED STATES

MELINDA GATES

When Bill and I started our foundation, we were focused on health and education, and I hadn't really thought a lot about gender equality. At the time, I certainly didn't expect that it'd become the cause of my life. But then I started traveling to the world's poorest places and spending time with the women who live there. That changed everything for me.

The women I met told me about losing their children to preventable diseases and struggling to provide for their families. They told me about repressive laws and customs that deny their daughters the opportunities their sons have. But they also told me about the transformation that happens in their communities when they are able to have an equal voice in their families and their futures.

These stories called me to action. I thought to myself: What was the point of their opening their hearts to me if I wasn't going to help them when I had the chance? After that, I decided I had a responsibility to find my voice as a public advocate and use it to amplify theirs.

In every country around the world, we still have work to do to achieve gender equality. It starts with listening to women, but it goes way beyond that. **We need to dismantle the systemic barriers that hold women back, promote policies that reflect the reality of their lives and ensure they have an equal say in the decisions that shape our societies.**

I'm an impatient optimist when it comes to this work. Equality can't wait, but progress is possible if we invest in it.

MELINDA GATES is co-founder of the Bill and Melinda Gates Foundation. She has helped forge a path towards gender equality through the power of her voice and impact of her investments.

BRAZIL

PANMELA CASTRO

WE HAVE LOTS OF STORIES of women in that time, before we had the law. Women would get to the police station and the policemen would ask what they did to deserve to be beaten.

When you are in a domestic violence situation, you are afraid to talk. Women just don't come out and talk about it. But if you have graffiti workshops and street art, everybody wants to get a spray can and paint—and in that moment, we talk about the law and all the tools that the law gave to women to protect ourselves. We teach them that they don't have to accept violence in their life.

I developed this methodology to use graffiti, which communicates with people, and adapted it for women's rights.

We work with women in domestic violence situations, and girls and boys, teaching them that no one deserves to suffer from violence.

I don't like this word "empowerment"; because, if you think about empowerment, it sounds like you are giving power to someone. **But you don't simply impart power when you empower someone; the power was always with them to begin with—you just helped them realize it.**

Today, in Brazil, we are fighting to not lose the rights that we already have. Not long ago, I would visit schools to talk about violence, but today, we cannot visit these schools. We decided to change our strategy: I opened an open-air museum offering the history of women and black people and types of domestic violence; and now, we bring groups with teachers that want to learn, and we talk with them as well.

PANMELA CASTRO is a Brazilian graffiti artist and founder of Rede Nami. Her art continues to shift culture around gender-based violence.

LEBANON & THE UNITED STATES

SARA MINKARA

I WOKE UP ON MY SEVENTH BIRTHDAY to find that I had lost my sight. I remember looking out the window, and the mountains that I had seen the day before were gone. I also remember my mom hugging me closely and telling me that everything was going to be OK—and it was.

My blindness is one of my greatest blessings. It has given me the gift of creativity and resilience—to think of innovative ways to interact with this world. My blindness has given me space to be my authentic self. I am able to engage with beauty in this world that is beyond the surface level.

Growing up, I was exposed to two worlds: one where I was empowered, and another where my blindness was seen as something to be ashamed of. My organization came from a commitment to ensuring that all individuals with disabilities know that they are valuable, and that society values them in return.

Most people think of disability inclusion in terms of human rights. We take it a step further, and advocate for a focus on value. We are a value to society, and our exclusion comes at a cost to us all.

"Nothing about us, without us" is a common phrase in the disability world. We need to be in the room if it's about us. I believe that each of us has the power to create an authentically inclusive world and to empower one another—and not because it is the "right" thing to do, but because it is only when we are all included that we can truly thrive as a society.

SARA MINKARA is the founder and CEO of Empowerment Through Integration (ETI). She is on a mission to disrupt the narrative around disabilities.

SOUTH AFRICA

PHUMZILE MLAMBO-NGCUKA

NO COUNTRY IN THE WORLD has attained a robust democracy without the women's movement, without civil society, and without an essential degree of feminist thinking.

We know that as early as six years old, children have already begun to internalize gender roles. Girls begin to think boys are smarter and must lead. But if, in class, a gender-aware teacher nips that in the bud, reverses the roles and gives girls the opportunity to be leaders in class, it creates a model of a society that we are aiming for.

Fighting for women's rights is a must, and not only for women. It also requires men to take a stand. **When good men do nothing in the face of inequality, when good men look the other way from violence against women, when good men joke about these issues, that actually gives perpetrators permission to carry on. That is why it is essential that we work together, with men and boys as allies, in achieving gender equality.** We have seen the power of men who refuse to be bystanders to gender-based violence in their families and communities, who support women in their workplaces and who step up to equally share the burden of unpaid care work in the home. With the rise of COVID-19, UN Women launched #HeForSheAtHome, an initiative for men to share the burden of care at home and fight the increase of domestic violence.

Working for gender equality is also affected by the inadequate resourcing of women's organizations. One thing these organizations have in common is that they are all underfunded. There is an expectation that gender equality somehow does not need investment—that it is not as important as other sustaining pillars in society. Yet if we fail to pay attention to gender equality through policies, financing, and change, we will leave women behind, and out of the digital world that we are so destined for. The fact is that a woman working on Wall Street, in a factory in India, and on a farm in South Africa, are all being underpaid. This makes the fight for equal pay a global one, and points to the universality of gender prejudice. That is what we must work to change.

PHUMZILE MLAMBO-NGCUKA is executive director of the UN Women and former deputy president of South Africa.

THE UNITED KINGDOM & SYRIA

ROLA HALLAM

BEING THRUST INTO WAR, when my country, Syria, went into flames, I soon made the discovery that the reason people survive in crisis was due to the remarkable work of the people in crisis themselves. People survived because of local doctors and aid workers from the heart of their communities—the people who will work where others can't or won't.

The international community does not recognize and support the local communities' self-reliant efforts. I saw this firsthand at one of the hospitals that I, as a Syrian physician, had set up. I realized that this was happening across the globe, and, as a result, millions of people are dying and suffering unnecessarily. We can deliver aid and save many more lives by enabling those local beacons of hope.

I believe that the system needs to change from being globally led to locally led and globally supported.

Instead of a white man or woman flying in and saying, "I know what's happening and how to fix it," we need them to ask, "What do you need and how can we help you?." It's a relationship of equals, based on dignity and respect for self-determination—helping people who are helping themselves.

As long as discussion remains primarily about gender rather than the qualities of leadership, it will take us much longer to get to a tipping point. (What tipping point? I'd say to move towards the just and peaceful world we want.) We have to be talking about the qualities that will make a difference. We will only progress once we transfer some of the respect given to masculine qualities to feminine qualities. I think we need to move the discussion away from the gendered scope and more towards rethinking what are considered the important characteristics of a leader... such as empathy, connection and care.

DR. ROLA HALLAM is a British-Syrian advocate who empowers local humanitarians to provide healthcare in war-affected communities, through her organization, CanDo.

IRELAND

MARY ROBINSON

MY PASSION over the last fifteen years has been to fight the injustice of climate change. Over that time, I have identified at least five layers of injustice:

1. People living in vulnerable countries, small island states and indigenous peoples are the worst affected, but the least responsible for emissions.
2. There is a huge gender dimension to the climate crisis because of the different social roles and power of women and men.
3. Children are now reminding us of the intergenerational dimension of the climate crisis— that we are not taking the right steps to guarantee that they will have a liveable future.
4. There is an injustice in the development pathways of industrialized and developing countries. Industrialized countries build their economies on fossil fuel and are now trying to move to clean energy. Developing countries need to develop but lack the investment, skills and transfer of technology to develop with clean energy.
5. We are causing a huge injustice to nature itself, and to the ecosystems that sustain us.

In recent years I have worked, in particular, with women leaders to address this challenge. We formed a group of Women Leaders on Gender and Climate in the UNFCCC system that helped develop a Gender Action Plan, and to have grassroots and indigenous women included in delegations to climate conferences. More recently, a number of women leaders adopted a Declaration on Climate Justice. I have also used humor in a podcast, *Mothers of Invention*, with its by-line—that climate change is a manmade problem with a feminist solution.

Now, we are faced with the immediate global health and economic crisis of COVID-19, and women leaders will have to be in the forefront of how we deal with this crisis. There are important lessons to be learned. COVID-19 is bringing home both our humanity and our global vulnerability. Although to protect ourselves we have to self-isolate or maintain social distance, we are also seeing neighbors helping each other and a major concern is to protect vulnerable groups in society. There is real fear of the threat posed, so we are willing to change our behavior.

It will be important when the immediate health and economic crisis of COVID-19 is over that we do not return to a fossil fuel-led business model. Women leaders will need to be at the forefront in making sure we transition to a fair, inclusive and sustainable future.

MARY ROBINSON was the first woman to serve as president of Ireland, a dedicated climate justice activist and impassioned advocate for gender equality.

MEXICO

ADRIANA HINOJOSA CÉSPEDES

I WAS ONE OF THE WOMEN who went on strike. All of the women in our office went on strike. I think we are very angry because gender-based violence has increased a lot in the past two years, but not only in the numbers—it's increased in the viciousness of the violence. We believe that the federal government is closing its eyes to this issue.

There are still many women who do not acknowledge that they are victims of gender-based violence in Mexico. **Violence has been normalized for a long, long time, and it has been treated as a private affair. Women are still really afraid to speak up and to visualize themselves as victims.**

We need a new view of how to address gender-based violence. We need to change our justice system. I do it on my state level, but we need change nationwide. We are working really hard to change old ways, and we have found a lot of resistance. But we're not going to give up hope.

I think that when a woman knows where to reach for help, we have half of the battle won. In Mexico, all institutions have their own numbers, their own information on the Internet. Something that really works outside of Mexico has been these efforts to make all the tools that help women in one space. We have to work towards it in Mexico.

DRIANA HINOJOSA CÉSPEDES, a former congresswoman, is the director of public policy in the Special Prosecutor's Office for Gender-Based Violence Crimes in the State of Mexico, and creator of the Gender Police force.

202

CAMBODIA

MU SOCHUA

I HAD LESS THAN TWENTY-FOUR HOURS TO PACK MY BAGS. We had a beautiful home, and a beautiful life. My people are beautiful people. It pains me to stay away from them. A few hundreds of my colleagues had to flee. Those in Cambodia had to go into hiding when our party was unconstitutionally dissolved. It's very painful.

Now that I talk a lot, that I am the face of the opposition, I worry. You never know. You don't want to touch these nerves. And the loneliness—I have to deal with that. My children want me home, my grandchild wants me home. It's difficult. However, serving democracy keeps me alive. And I refuse to slow down.

I always look at the reality—not just theory, not just policy, but all of it together. So, I would go to brothels. I would go to factories. I would go to demonstrations. I did this to build trust with the people whose lives we are talking about, and to say, "What you are going through, we need to know and we need to defend it, no matter who you are." As a member of parliament or as a minister, I would go to parliament and leaders and say, "Listen, when I talk about gender-based violence, when I argue land rights, for this article, that law, I know what I am talking about, I have heard the voices of the people."

Get into politics. Throughout the world, there aren't enough women in politics. Politics must be defined by the action on the streets. Cambodian women are always, always, on the frontline at every single protest—it is a tribute to their courage and to the sacrifices they have made. We need our women, especially the young ones, to get into politics and take my place.

MU SOCHUA is vice president of the Cambodia National Rescue Party, where she has fearlessly exposed government corruption and human-rights abuses.

THE UNITED STATES

JENNIFER SIEBEL NEWSOM

I THINK THE BEAUTY OF DOCUMENTARY FILM is that you can educate people while taking them on a narrative journey that moves them emotionally. This particular film medium can really awaken people's consciousness causing shifts in attitudes and behaviors, and ultimately transform culture.

The main reason I started The Representation Project was that I saw both an underrepresentation and misrepresentation of women in media that directly contributed to the underrepresentation of women in leadership. The statistics reflected this. But there had not been enough of a cultural conversation about the dangerous impact of the normalization of limiting gender norms.

When I think, in particular, about violence against women, I think about the root cause. To me, it stems from these attitudes and values that place the masculine over the feminine—putting power, dominance and control over empathy, care and collaboration. Violence against women has been, in many ways, normalized around the world because of our history of putting more value on male leadership and therefore masculine traits. This will continue until we acknowledge the unbalanced gender hierarchy and re-embrace the feminine.

To create real cultural transformation and a leadership shift, we have to affect change at both the individual and communal or institutional levels. We have to awaken ourselves individually to the subconscious biases that devalue the feminine inside us or in others, thereby holding us back as a larger society. And, at the communal or institutional level, we have to create space for the feminine and support a more transformative or feminine style of leadership—whether it's in a woman, a man or someone who is non-binary. It needs to be less about transactional leadership and dominance—a win at all cost model—and more about our collective well-being and communal prosperity. It needs to be a partnership-oriented leadership style.

JENNIFER SIEBEL NEWSOM is first partner of California, and co-founder of The Representation Project, a film organization that advocates for gender equality and exposes damaging societal and cultural norms that hold us back.

PAKISTAN

MALALA YOUSAFZAI

I TELL MY STORY not because it is unique, but because it is not. It is the story of many girls. I speak—not for myself, but for all girls and boys. I raise up my voice—not so that I can shout, but so that those without a voice can be heard.

MALALA YOUSAFZAI is the youngest-ever Nobel Prize laureate, founder of the Malala Fund, and an advocate for girls' education who showed the world how to turn hatred into positive change for millions of girls.

GHANA & THE UNITED STATES

BOZOMA SAINT JOHN

WHEN PEOPLE READ MY TITLE or hear my resume, they assume that my work operates from a place of distance in large corporate structures. And while that is somewhat true, the reality is that I'm in the feelings business; therefore, I'm up close and personal with my audiences. Of course, there's data collection, creating strategy and writing plans to move a business or people in a certain way; but in my work, I move them by identifying their emotional state, and evolving it this way or that to match our objectives. That's been the cornerstone of my career: I understand my feelings and I trust that I can understand theirs.

Generally speaking, women in our modern societies are given more allowance to be in touch with their feelings. That is the amazing thing about women—but our power has ebbed and flowed over the centuries. We are coming into another phase of our power, in which we do need to utilize all of our feelings and emotions. If we return to that place of intuition, we will recapture our power.

My family moved from Ghana to Colorado Springs when I was twelve. And as you can imagine, I stood out. But, being twelve, I didn't want to stand out. And my mother in her power was very conscious of making sure that we understood what and who we were and how unique and special that was; and that was a gift that has served me again and again.

Throughout my life, I have been able to move into spaces where it was expected for me to assimilate into the culture; but I have said, "No." I've shown up as my whole self—not dumbed it down or shaved off the edges for anybody else.

BOZOMA SAINT JOHN is the chief marketing officer of Endeavor, and shows the world the importance of living authentically and showing up proudly.

SOUTH AFRICA

GINA BARBIERI

THE INJUSTICE OF APARTHEID and the slow transformation that followed in people's hearts led me into human rights law and mediation. I tend to get involved where I see a need—and right now, the need is to address the vast disparities in women's access to almost everything. We need to develop a way to communicate with each other that expresses kindness, tolerance, understanding. It is only through the full and proper participation of all of us that we will find the right answers to our most challenging issues.

I spend a lot of time thinking about how we can help people—particularly women—find their voices, and articulate their needs and their desires in a way that institutions can hear, and do something about it. Empathy that leads to action is a driving force; and I want to make sure that this driving force enhances women's participation at all levels of development, from grassroots participation to policy reform.

> I think we need armies of women mediators—that's my dream, deployed in communities, in refugee camps, on the frontlines of policy reform and institutional transformation—armed with skills that commands them a seat at the table crafting solutions collaboratively.

Finding power from within is a big step forward. I think that as women, if we seek power only within existing institutions, our motives are out of alignment with true transformation. Power lies in all of us—we need support and access to resources to harness that power.

GINA BARBIERI is a human rights lawyer and mediator from South Africa who dedicated her career to conflict resolution.

COLOMBIA

CLAUDIA LÓPEZ HERNÁNDEZ

F ROM THIS CHALLENGE we are facing, it will not be the wealthier or stronger that emerge victorious, but the most disciplined, public-spirited and generous.

CLAUDIA LÓPEZ HERNÁNDEZ is the major of Bogota, Colombia, and the first woman to hold the second-most important office in Colombia.

ABOUT THE EDITOR

ALYSE NELSON is president and CEO of the international non-profit Vital Voices Global Partnership. A co-founder of Vital Voices, Alyse has worked for the organization for more than two decades, serving as vice president and senior director of programs before assuming her current role in 2009. Under her leadership, Vital Voices has expanded its reach to serve over 18,000 women leaders across 182 countries. In 2021, they will open the first-ever Global Headquarters for Women's Leadership.

Previously, Alyse served as deputy director of the State Department's Vital Voices Global Democracy Initiative and worked with the President's Interagency Council on Women at the White House Chaired by Hillary Clinton and Madeleine Albright. Alyse is a Member in the Council on Foreign Relations and serves on the Boards of Running Start and RAD-AID. She is on the Advisory Boards of Chime for Change and Global Citizen. Fortune Magazine named Alyse one of the 55 Most Influential Women on Twitter, Newsweek featured her one of the 150 Women Shaking the World and Apolitical has recognized her as one of the 100 Most Influential People in Gender Policy. Alyse has received numerous awards including the Tribeca Disruptive Innovation Award.

Alyse is the author of the best-selling book *Vital Voices: The Power of Women Leading Change Around the World*, hosts Vital Voices' Podcast and has been featured in various international and national media. She lives in Washington, D.C., with her husband Hardin Lang and their two young children.

ABOUT THE ARTIST

GAYLE KABAKER is an award-winning painter, writer and visual storyteller. She went to the Academy of Art in San Francisco and began her career as a freelance fashion illustrator. She had her first *New Yorker* magazine cover "June Brides" celebrating gay marriage in 2012, and has had a total of five covers since then. Her work tends to be very feminine, exploring beauty in all forms. Traveling to paint and draw is a big part of Gayle's life, and she uses her sketchbook to document her life. She lives in Western Massachusetts with her husband, artist Peter Kitchell and their dog, Charlie.

Gayle says, "Painting such a wide range of women of all ages, from all over the world and 'getting to know' each of these amazing, strong, brave women by reading about them and studying their faces carefully from photos in order to catch their likeness in a painting, has felt like such a privilege. It's been quite an education. Sometimes uplifting and exciting, other times, really painful to realize the tragedies in these women lives that led them to become activists. I am so lucky to have an amazing creative collaborator in Vital Voices CEO and co-founder Alyse Nelson, who gave me lots of creative freedom to let each painting dictate what felt right. This has been one of the most rewarding projects I've ever worked on."

ACKNOWLEDGMENTS

With great appreciation to those who made this book possible: in particular, to Jean Christian Agid; and to Esther Kremer and the team at Assouline, for your passion for this project and commitment to raise these voices. To our extraordinary editor, Vikki Loles, our diligent project coordinator, Leslie Smith, and our committed research assistant, Jackson Prettyman; and to our entire talented team at Vital Voices for their support and creative counsel—in particular, Jennifer Smith, Lauren Wollack, Lizzie Kubo Kirschenbaum and Leslie Warren.

A huge thank you to the brilliant photographers whose work inspired many of the portraits: Aaron Kisner, Teresa Osorio Ochoa, Erika Pineros and Micky Wiswedel.

ONETREEPLANTED

Assouline supports *One Tree Planted* in its commitment to create a more sustainable world through reforestation.

© 2020 Assouline Publishing
3 Park Avenue, 27th Floor
New York, NY 10016 USA
Tel: 212-989-6769 Fax: 212-647-0005
assouline.com

ISBN: 9781614289784
Printed in Turkey

All rights reserved. No part of this publication may be reproduced or transmitted in any form or by any means, electronic or otherwise, without prior consent of the publisher.

vi·tal (ˈvīdl) *adj.* **1a.** existing as a
with or necessary to the maint
vigor: ANIMATED **3.** fundamentally
or living beings **b.** of the utmost

voice (ˈvȯis) *n.* **1a.** sound produ
lungs, larynx, or syrinx; *esp*: sour
2a. wish, choice, or opinion ope
the people] **b.** right to expressi
to express in words: UTTER **syn** se